ALFRED HAMBROOK'S MID KENT

THROUGH TIME

Andrew Ashbee

AMBERLEY PUBLISHING

First published 2010

Amberley Publishing Plc
Cirencester Road, Chalford,
Stroud, Gloucestershire, GL6 8PE

www.amberley-books.com

Copyright © Andrew Ashbee, 2010

The right of Andrew Ashbee to be identified as the
Author of this work has been asserted in accordance
with the Copyrights, Designs and Patents Act 1988.

ISBN 978 1 84868 934 3

British Library Cataloguing in Publication Data.
A catalogue record for this book is available from
the British Library.

Typeset in 9.5pt on 12pt Celeste.
Typesetting by Amberley Publishing.
Printed in the UK.

Introduction

Alfred Nethersole Hambrook (1876-1955) served an apprenticeship as a 'printer (compositor)' in the 1890s, when he was living at Halling, which may have been with one of the Snodland printers in the next parish. In any event in 1901 he took on the shop of Charles Sprowson in Snodland High Street and it retained his name for more than fifty years. From his works in May Street he produced much of the ephemeral printed material required in the village, and also a large selection of postcards which were distributed around Kent. It was unfortunate, but understandable, that all his plates were destroyed after his death, because they covered a whole floor – and there was not then the interest in them which exists today. Snodland Historical Society is making an effort to collect what it can of Hambrook's work, particularly the postcards, and it is hoped that one day a proper study of them will be produced.

The selection in this book is restricted to pictures of villages and hamlets within about a dozen miles of Snodland. 'Mid Kent' may be something of a misnomer, since they are all in the west of the county, but no other tag comes to mind which would serve as well.

Hambrook's earliest cards seem to date from 1904, but soon he and others embarked on their 'Kent Series'. These are mostly coloured and some images seem to have been shared between photographers, each issuing them under their own name. Around this time Hambrook also described himself as 'Managing Director' above the door of Stedman & Co.'s Abbey Press in West Malling High Street, and it is noticeable that many of Stedman's pictures have the same style as Hambrook's at this time. A few cards are labelled 'Stedman and Hambrook' (such as the four West Malling pictures in this book), but Stedman alone is generally attributed on cards of West Malling and district. There seems to have been some agreement between photographers as to who would cover particular areas, so we find no Hambrook images of Maidstone and district, but plenty by him of the Medway Towns.

Many of the pictures in this book come from a numbered series attributed to 'H Bros S' ('Hambrook Brothers, Snodland'). Together with his brother Percy, Alfred set up a commercial operation, supplying postcards to villages and towns. It is not always easy to identify these cards, since they may rather show the name of the local shop where they could be bought: Peters at Birling, Bolton at Burham, for instance. The style of the captions and multi-view cards can offer clues to help identification. Also there are links between the groups: coloured 'Kent Series' postcards also occur as sepia 'H Bros S' cards, numbered or un-numbered, or were part of a third series with wide margins and a mauve-ish print which date from around 1907 onwards.

Evidence from postmarks, and often from the images themselves, indicates that the bulk of the 'H Bros. S' numbered series dates from before about 1920. After that date Hambrook seems to have produced fewer cards, although they continued into the 1940s. Also he often re-visited places and scenes which he had photographed years before. A final group appears under the auspices of E. A. Sweetman & Son of Tunbridge Wells, with cards acknowledging copyright to A. N. Hambook.

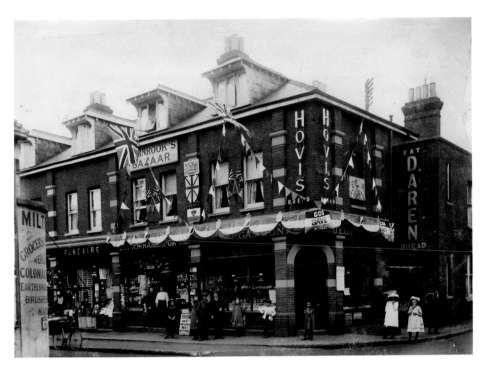

Hambrook's Shop in Snodland High Street

The decorations are to celebrate the coronation of George V, held on 22 June 1911. Today the shop is still a stationer's and there is still a bakery next door. Very few shops in the town have retained their original trade as these two have.

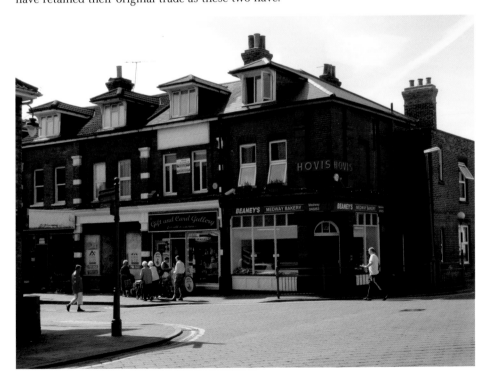

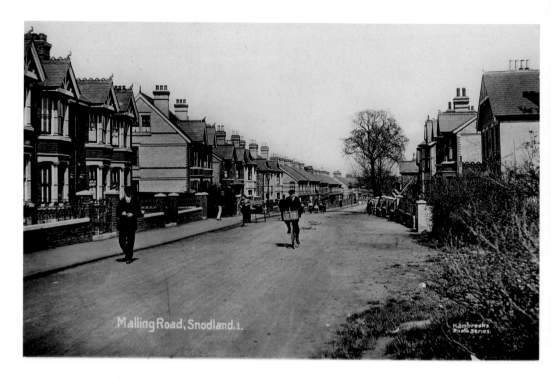

Malling Road, Snodland. 1.

Hambrooks Photo Series.

Upper Malling Road, Snodland

The houses in this part of Malling Road were built in the 1890s and early 1900s, so most are still quite new in Hambrook's photograph of *c.* 1910. His view looks north from outside the gate of Christ Church. A footpath on the right gradually spread up the hill, but had not reached this succession of semi-detached houses by then. Demolition and bomb damage removed several properties later, but all is neat and tidy again in the modern image.

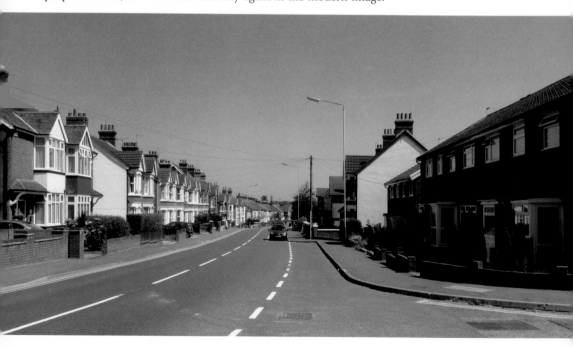

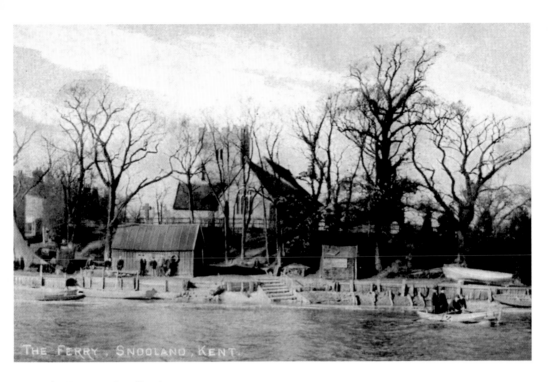

The Ferry at Snodland

There seems to have been no official ferry between Snodland and Burham until the 1840s, although this was a very ancient crossing point of the river. The ferry became very active from the later nineteenth century transporting workers to and from the numerous cement factories. After their closure its use gradually declined and it too was closed in 1948. Today only the ferry house remains.

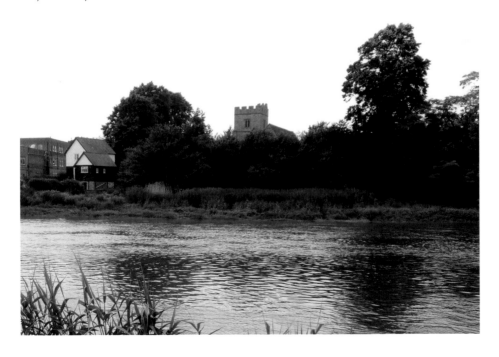

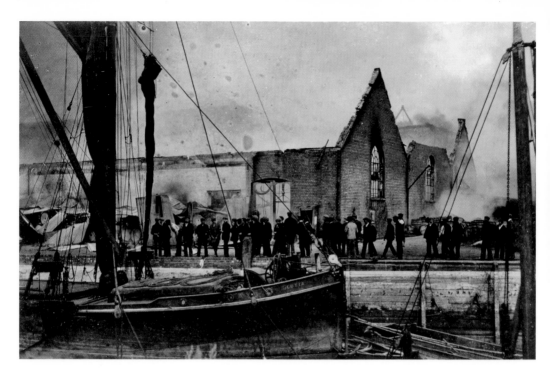

Snodland Paper Mill

Hambrook was one of many photographers who rushed out pictures of the great paper mill fire of 12 August 1906. The barge *Scotia* was later repaired, but her companion *Vulture* was lost. Both belonged to E. C. Goldsmith & Co. Today the creek where they lay is no longer accessible to ships and all deliveries to and from the mill are made by road.

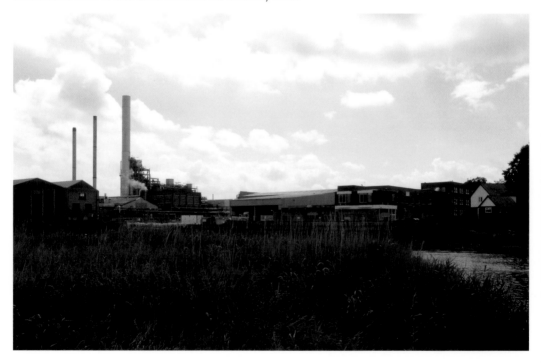

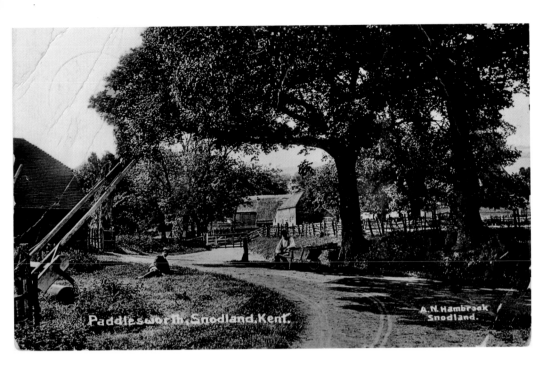

Paddlesworth, Snodland, Kent.

A. N. Hambrook
Snodland.

Paddlesworth

This delightful view of Paddlesworth from the east cannot be replicated today. The road has been straightened, the trees with their welcome shade have been removed and there is no verge on which to rest. Obstacles for traffic, such as the stump in the road and the gate (one of several needed to keep livestock penned) have also disappeared. The seventeenth-century barn appears in both pictures, but only the latest farmhouse can be seen; earlier ones are hidden by the trees.

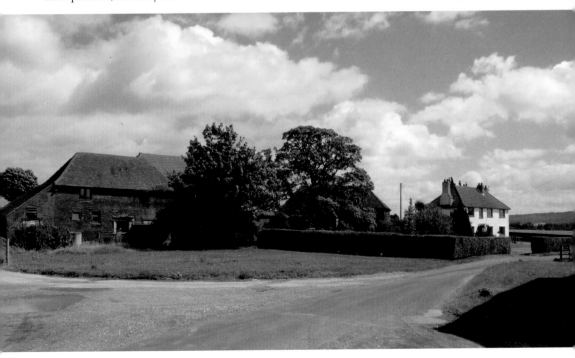

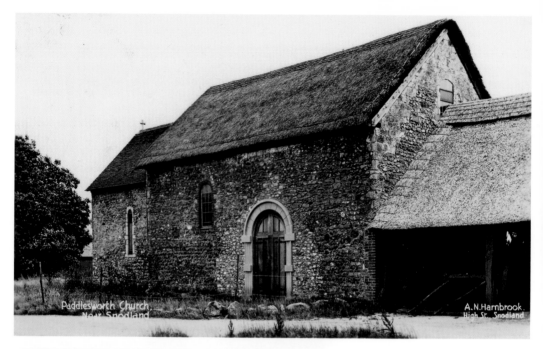

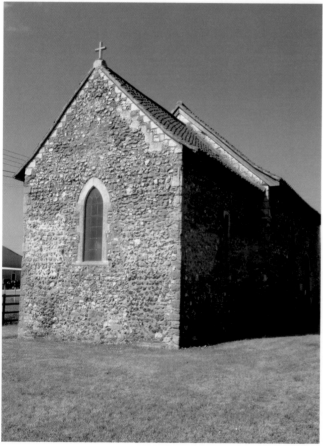

Paddlesworth Church
The Roberts family of Holborough Court acquired Paddlesworth from the Nevills of Birling in 1928. The little Norman church had been a barn since the seventeenth century, but in 1933 it was restored as a private chapel. Hambrook's picture shows it after the work was completed. The lighter stones surrounding the door show what originally was a large opening for farm implements. Today the church is cared for by the Churches Conservation Trust and is open for visitors.

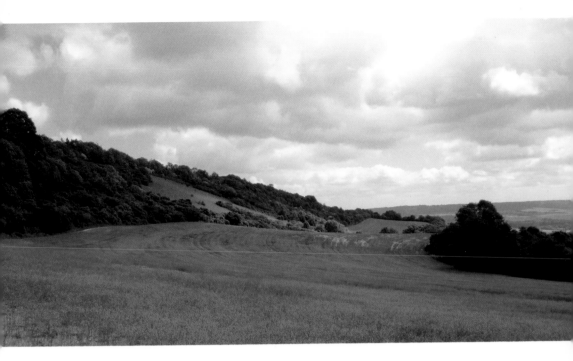

The North Downs above Snodland

Hambrook took at least a dozen photographs of the hills above Snodland and Birling. 'Sixteen Acres' shown here has always been popular for picnics and the views towards the south are very fine. The Pilgrim's Way runs along the foot (and is hidden in the trees on the right of the modern picture).

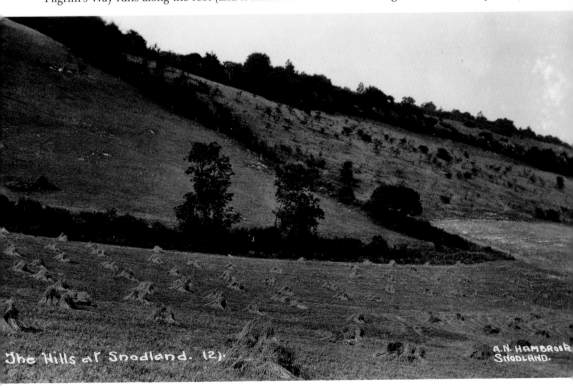

The Hills at Snodland. (2).

A.N. HAMBROOK
SNODLAND.

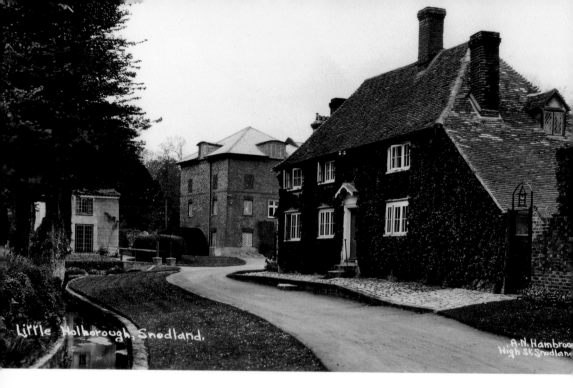

Little Holborough, Snodland.

A.N. Hambroo
High St. Snodland

Snodland, Mill Stream Cottage
The sole survivor of what was once a street of ancient houses at Holborough, and probably the finest of them, this was the Cock Inn owned by the Gilder family for much of the eighteenth century. It had a farm of 22 acres attached to it from at least the mid sixteenth century to the nineteenth century.

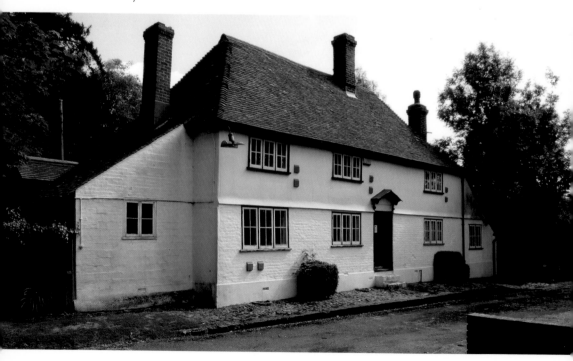

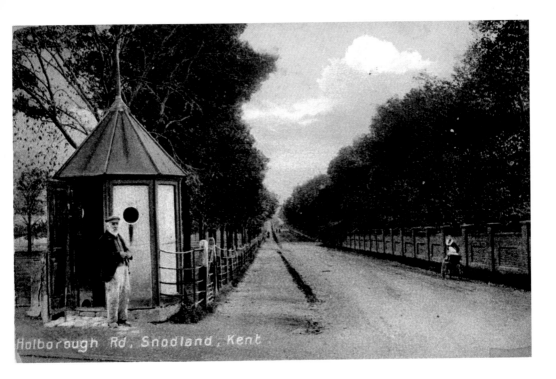

Holborough Road

The view south from the Snodland-Halling boundary in 1905. The Holborough Court estate was behind the wall on the right. Here lived the owners of Lee's cement works, whose trucks filled with chalk were a danger as they freely descended from the pit to the works. The little hut was for the man with a red flag who halted traffic as the engineless train hurtled across the road. The road was made a dual carriageway in 1984.

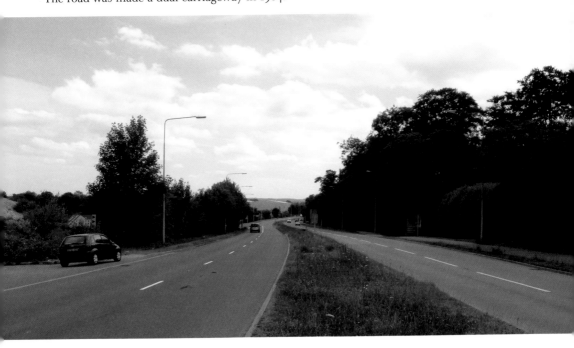

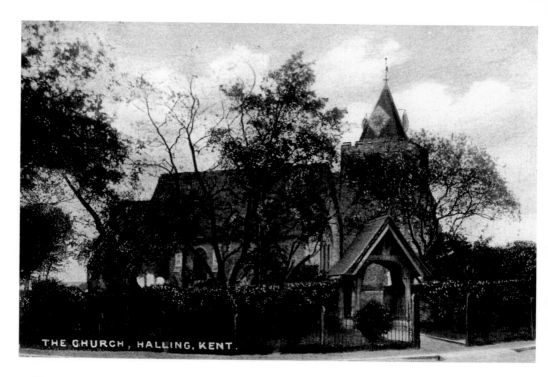

THE CHURCH, HALLING, KENT.

Halling Church

The view of 1905 is one of Hambrook's coloured 'Kent Series'. In the modern photograph the churchyard is on the right of Ferry Road leading down to the former Halling-Wouldham ferry across the Medway. On the left is Manor Cottage, where Hambrook grew up. As foreman at Hilton and Anderson's cement works for many years, Alfred Hambrook senior was entitled to this imposing property.

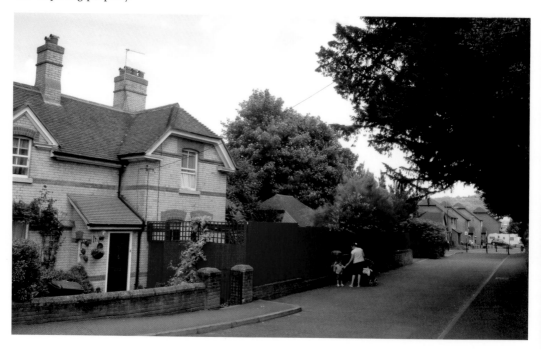

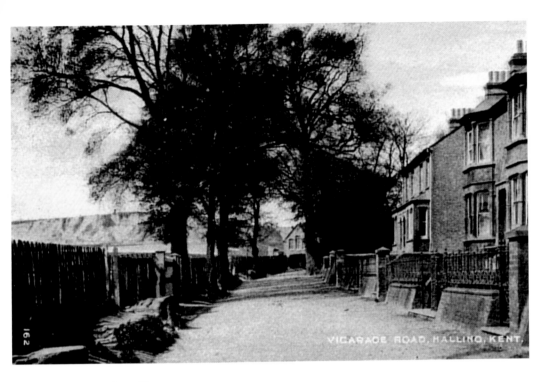

Vicarage Road, Halling

The 1905 view is further west than the modern one, but both show the substantial houses on the right which were intended for the professional classes rather than labourers. Censuses show that they are given individual names: 'The Ferns', 'St Osyth', 'St Elmo' and the like, but the inhabitants remain a mix: surgeon, builder, clerk, farmer, as well as labourers, the latter no doubt employed in the pit opposite.

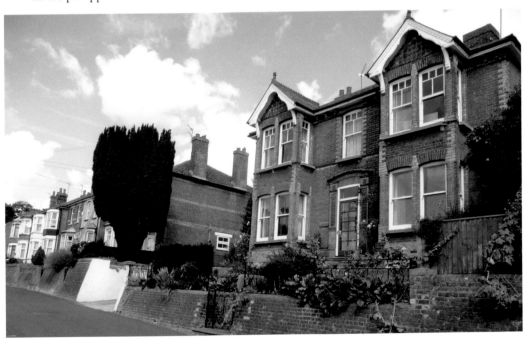

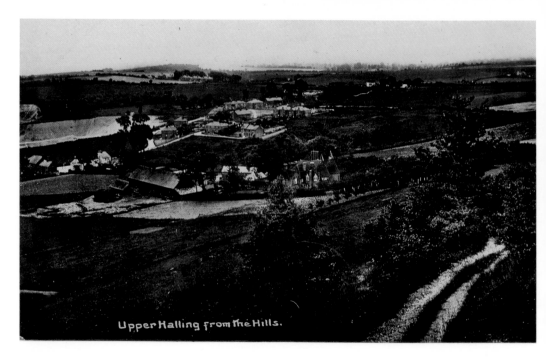

Upper Halling from the Hills.

Upper Halling

Court Farm is in the centre foreground. Its name suggests it may have been used as a manorial meeting place at one time. Fifteenth-century features remain internally, but part of the original hall house was demolished about forty years ago. Many of the Upper Halling buildings look new in the old photograph. The chalk pit on the left, long since abandoned, is now disguised by vegetation.

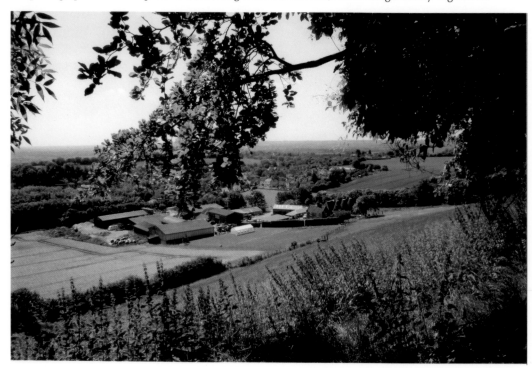

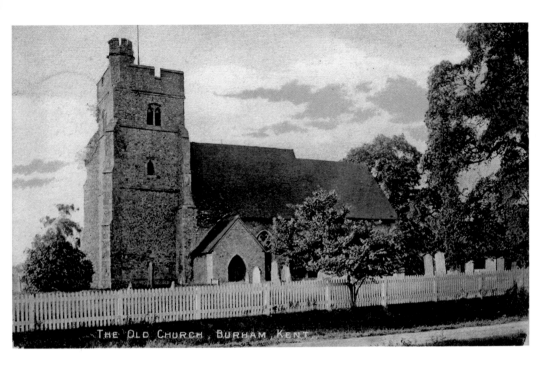

Burham Old Church

Its isolated position near the river caused a new church to be built in the main village in 1881. Unfortunately that became unstable and was demolished in 1980. The Old Church of St Mary is in the care of the Churches Conservation Trust. An unusual feature is that side aisles were built, but demolished again, as evident in the blocked up arches, visible both internally and externally.

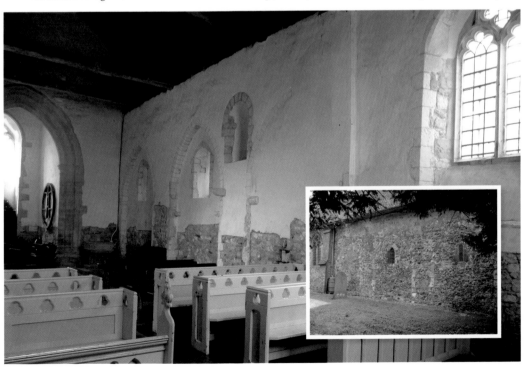

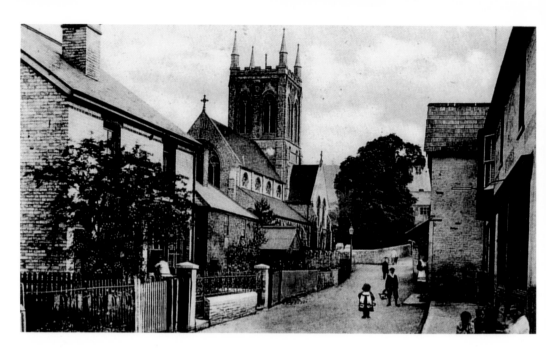

Burham, Church Street Looking East

St Mary the Virgin, built in 1881 by E. W. Stephens of Maidstone, had to be demolished in 1980 when it became unsafe. Hambrook photographed it *c.* 1905 and, as he often did, used the tower as a vantage point. Today houses occupy the site.

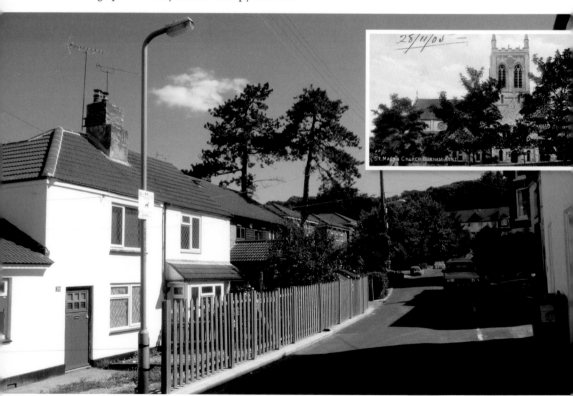

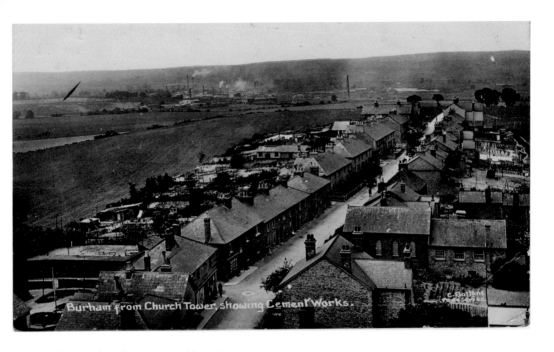

Burham from Church Tower, showing Cement Works.

Burham, Church Street Looking West

Hambrook took this picture from the tower of St Mary's, the Victorian church. Today the Anglican parishioners share the Methodist church seen in the foreground. The distant chimneys are of the Burham Brick, Lime and Cement works. Thomas Cubitt built much of London with bricks from here. The modern view (using zoom lens) is from the west end of the road showing part of Snodland and Paddlesworth, with Burham's old St Mary's church in the foreground.

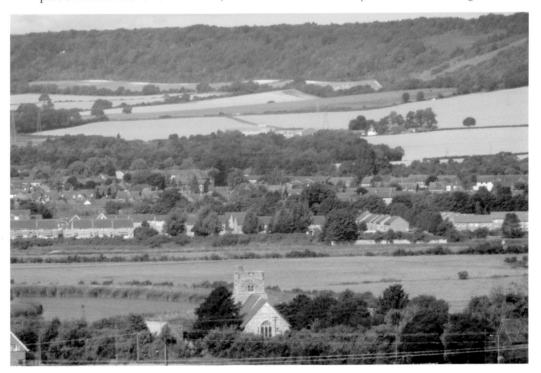

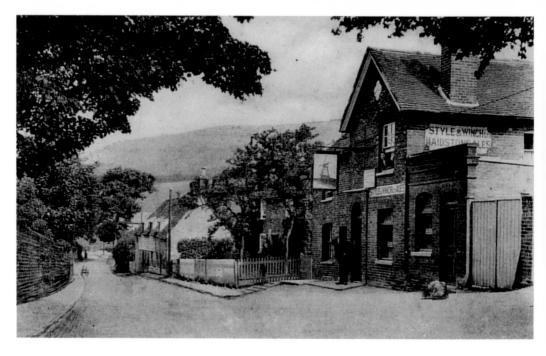

Burham, 'The Windmill'

Hambrook's picture dates from around 1908. The road to Rochester is now widened for modern traffic and the old houses are gone, replaced by a garage. 'The Windmill', built in 1847, is much as it was, although the brewers Style & Winch closed in 1965 and their impressive riverside brewery in Maidstone was soon demolished.

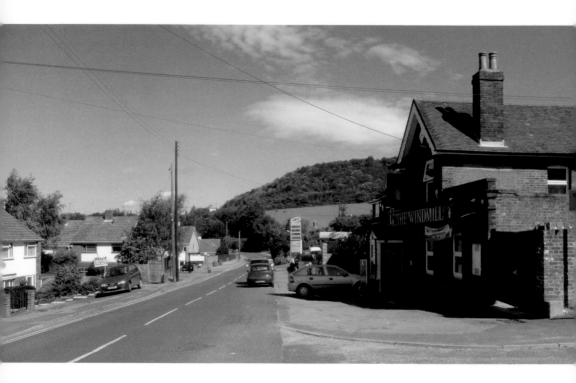

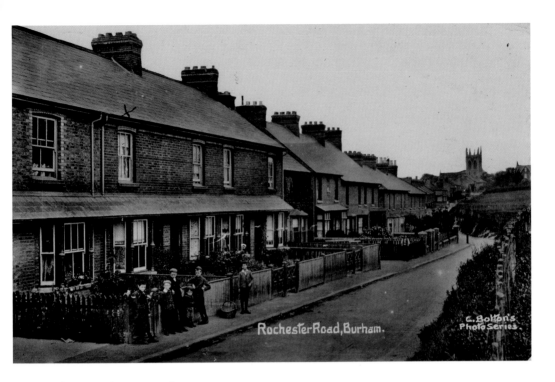

Burham, Rochester Road

Victorian and Edwardian houses like these, originally for cement workers, are plentiful in Burham, as they are in the neighbouring villages of Wouldham and Eccles. They have served their communities well. Today the village hall is situated on the right (east) of the road.

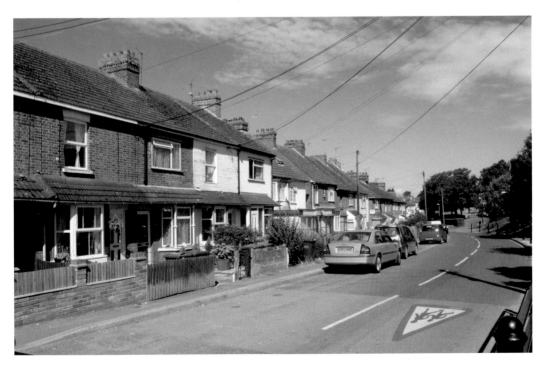

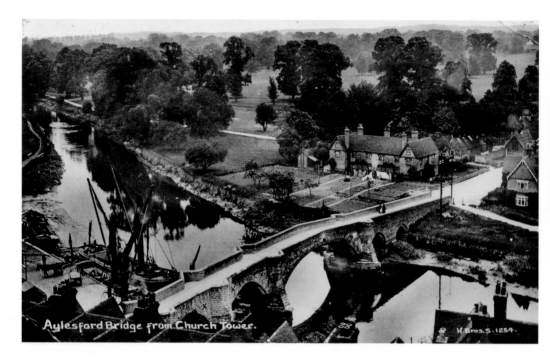

Aylesford Bridge from Church Tower.

Aylesford Bridge

The medieval bridge was the only one to cross the Medway between Rochester and Maidstone. Its centre arch was widened in 1824 to take the busy barge traffic. No longer do double-decker buses have to squeeze their way over it, for a new bridge now crosses the river further to the east. On the south bank the fields are now covered with houses, including these latest fashionable ones in a pseudo-warehouse style.

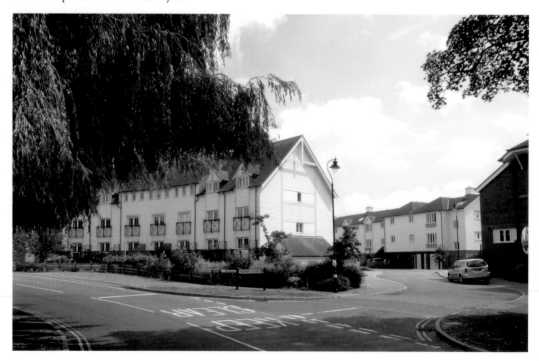

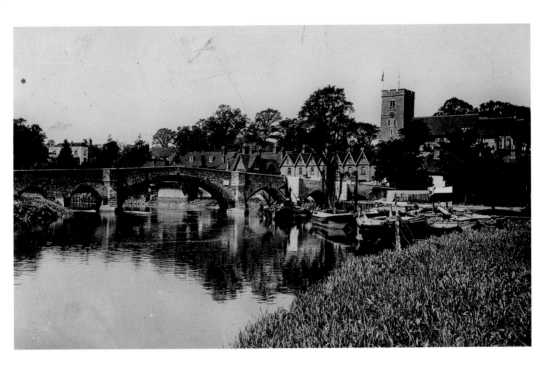

Aylesford from the South-East

This classic view of Aylesford can today be matched by a photograph from the new bridge. The barges have gone, but their hard standing is still visible at low tide, as the modern picture shows. Apart from the wharf and its activity, nothing seems to have changed.

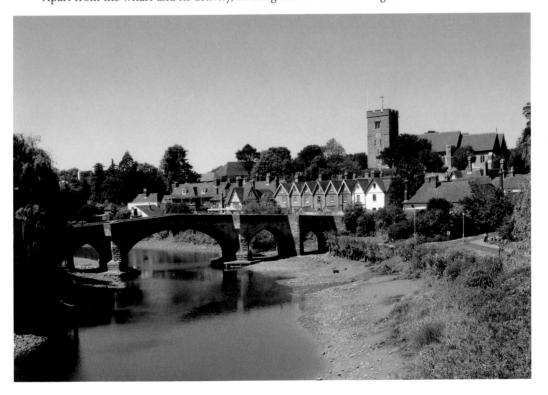

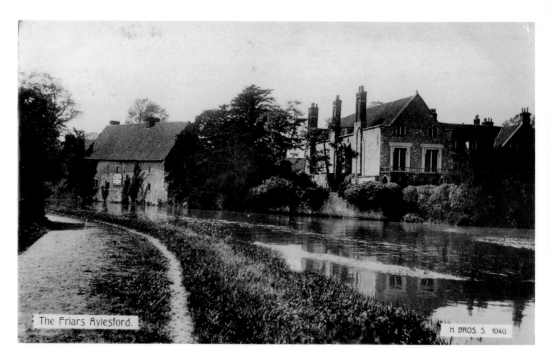

The Friars Aylesford.

H. BROS. S. 1040.

Aylesford, The Friars

Hambrook took several pictures of The Friars at Aylesford around a hundred years ago, at which time it was owned by the Earls of Aylesford. The Carmelite Friars came here in 1242, but lost their home in 1538 at the Dissolution of the Monasteries. It passed through the hands of several important families until 1949, when the Carmelites were able to purchase it again. It is now an important centre of pilgrimage, with many new buildings.

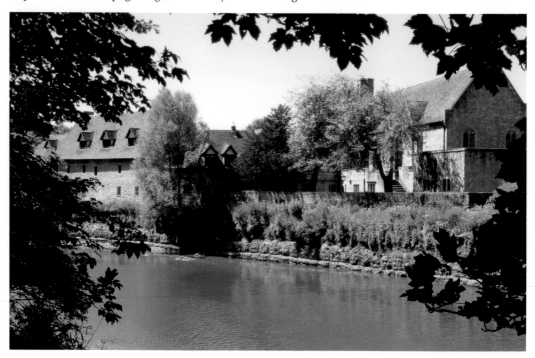

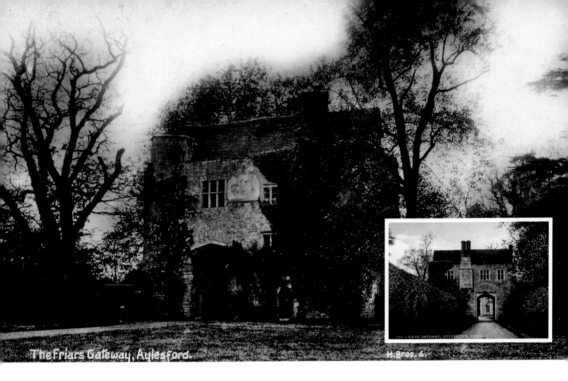

The Friars Gateway, Aylesford.

H. Bros. S.

Aylesford, Gatehouse to The Friars

The gatehouse to The Friars is separate from the main buildings and once housed lodgings for the porter. The building was restored in 2003 and now serves as a centre for quiet meditation. The inset, one of Hambrook's 'Kent Series', shows the approach to it from the north.

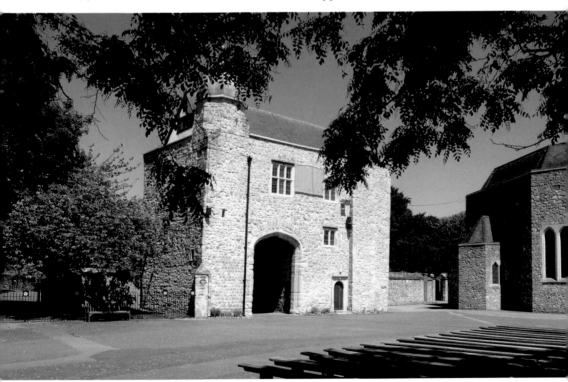

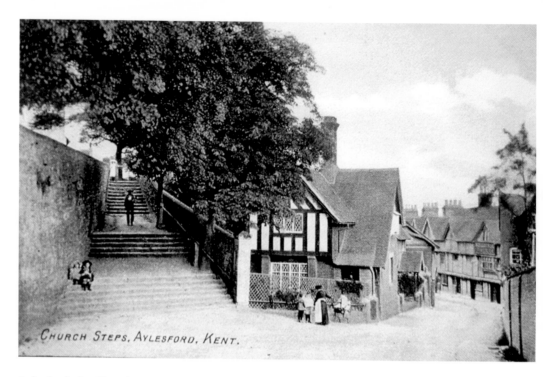

Aylesford, the Church Steps

The church of St Peter and St Paul towers over the village, and it is a steep climb to reach it from the High Street from east or west. This view has not changed in a hundred years.

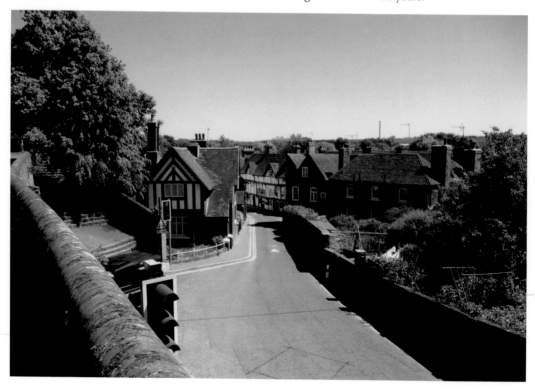

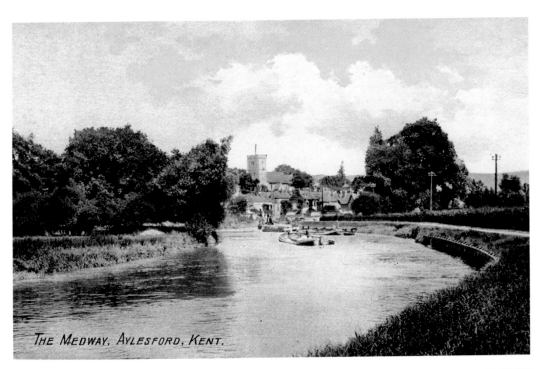

THE MEDWAY, AYLESFORD, KENT.

Aylesford from the South-West
In spite of the best efforts of the photographer, it was not possible to capture a matching modern view of Aylesford from the south-west. Presumably the path was once kept clear so that it could serve as a tow-path, but now the bank is lined with trees and other foliage, and modern buildings have sprung up behind.

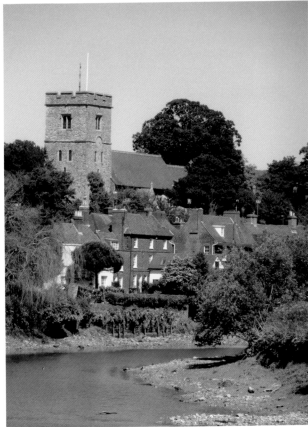

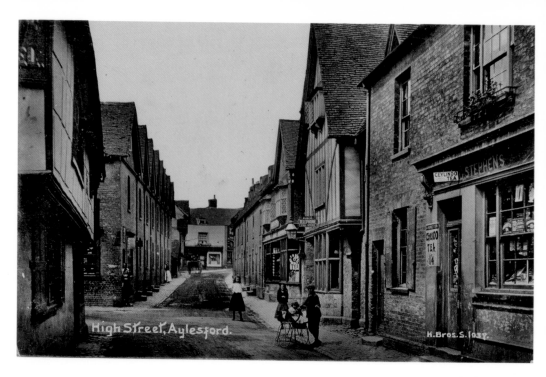

Aylesford, the High Street Looking West

Another unchanged view since Hambrook took his picture in the early 1900s. However, vehicular access to the medieval bridge (on the left) is now prevented and traffic lights control movement through the High Street. The eight terraced houses on the left were built in 1840 and are a striking landmark both from the street and from the river side.

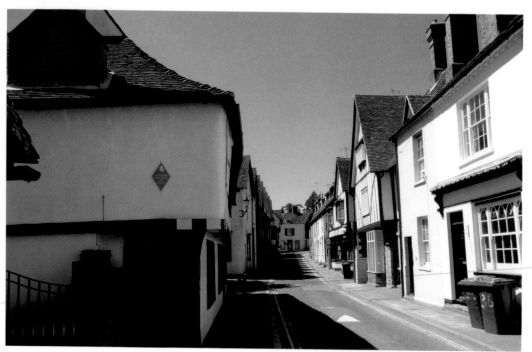

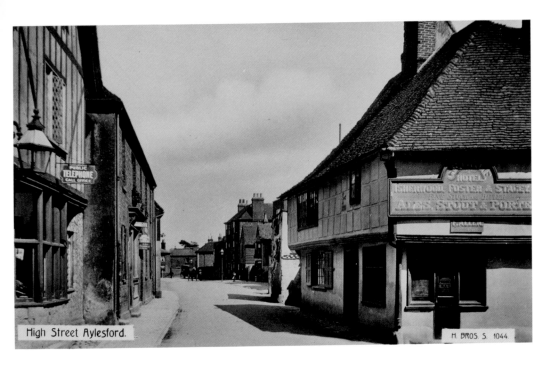

Aylesford High Street Looking East
A view of the High Street towards Maidstone. The mid sixteenth-century George Inn on the right (formerly 'The Windmill and George') has been a private house since 1968. The way from the medieval bridge enters from the right. Note the public telephone advertised on the shop front.

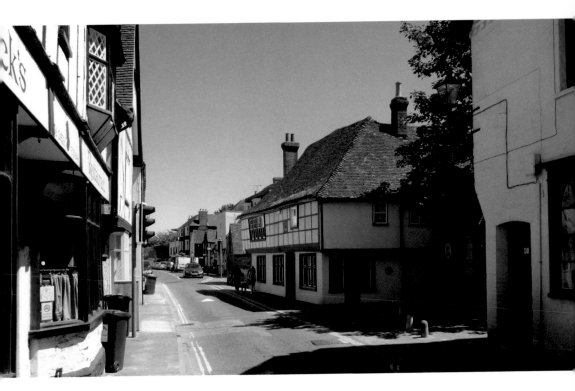

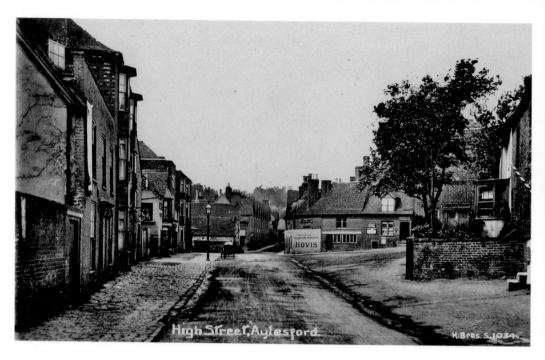

Aylesford High Street Looking West

Of all the Aylesford views this one has changed the most. The varied old buildings on the left (south) remain, but in the mid twentieth century those on the right were replaced by modern accommodation for the elderly.

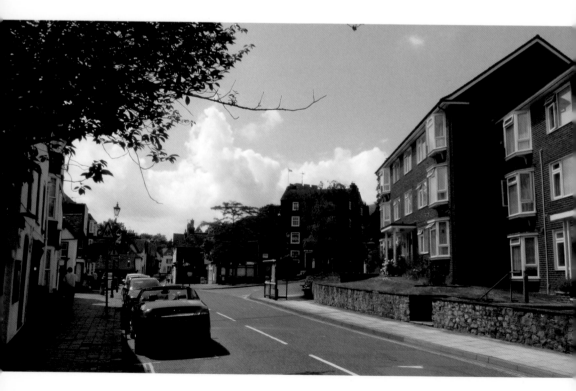

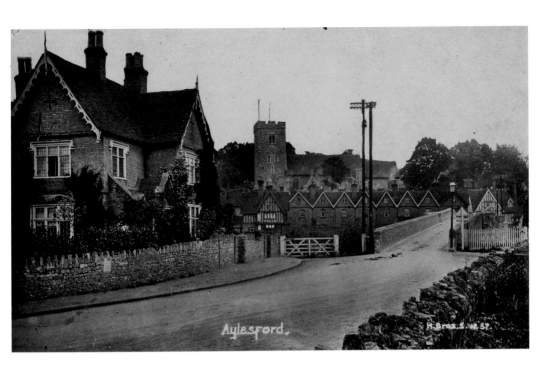

Aylesford from the South

It is no longer possible to photograph this view of Aylesford from here, for a large tree blocks all sight of the buildings on the north bank. The photographer has moved forward to one of the refuges for pedestrians on the medieval bridge, very necessary when this was the only means of crossing for carts and vehicles.

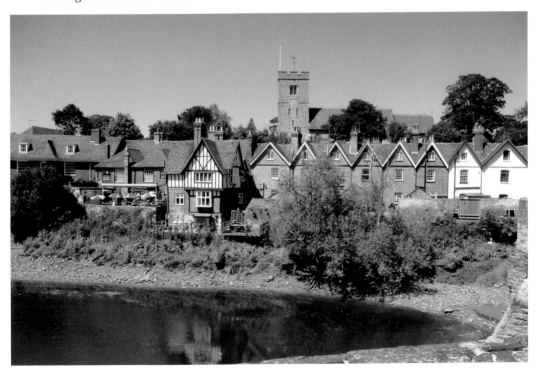

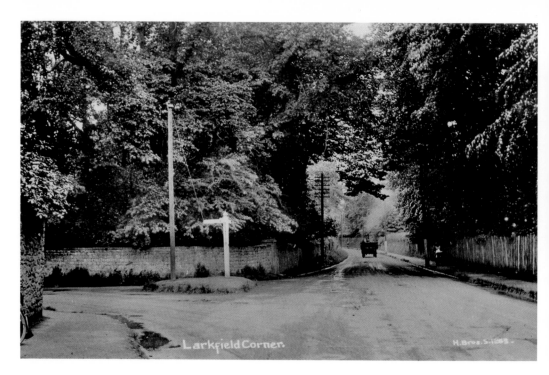

Larkfield: the London Road

No doubt virtually all traffic using the London Road was horse-drawn when Hambrook took his picture around a hundred years ago. The turning to East Malling is on the left. Today this very busy road needs all the safety features of barriers, traffic lights central reservations and crossings to guide pedestrians and vehicles.

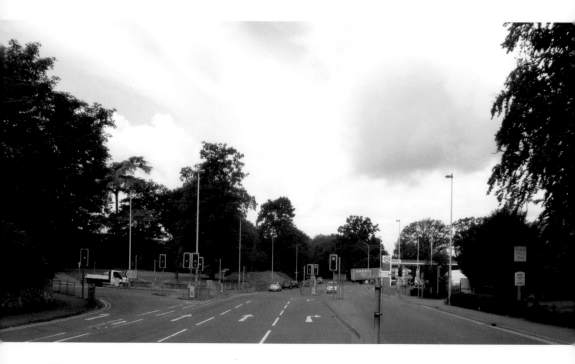

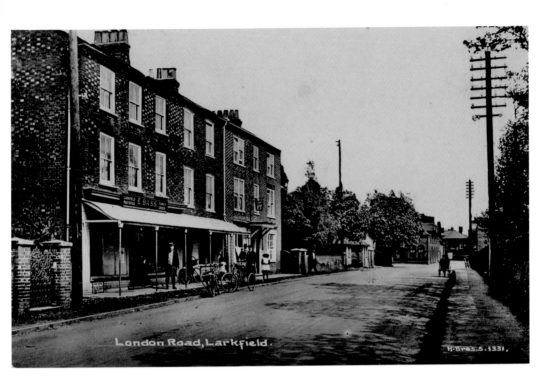

London Road, Larkfield.

Larkfield: London Road

It is disheartening to see attractive buildings and scenes in old photographs altered to their detriment by 'progress'. The integrity of this pleasant group of town houses and shops, pictured around 1920 – with uniform brickwork and windows – has been destroyed by varied facing, replacement windows and especially the brash plastic shop signs.

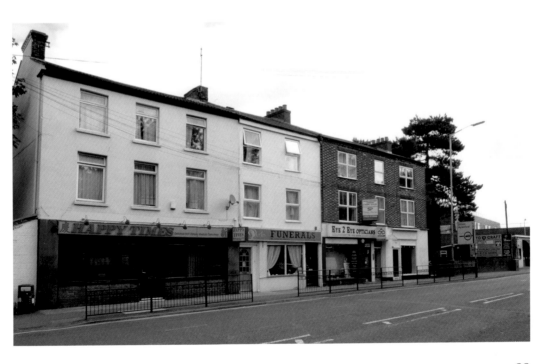

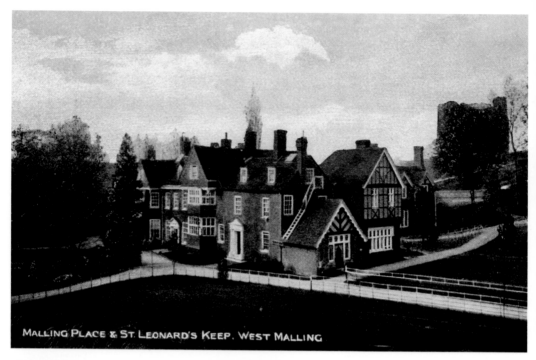

MALLING PLACE & ST. LEONARD'S KEEP. WEST MALLING

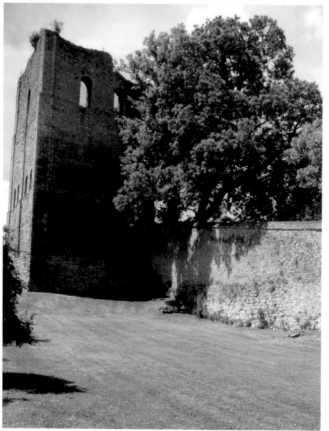

West Malling,
St Leonard's Tower
The tower is attributed to
Gundulf, bishop of Rochester
(1077-1108), who built it
to oversee his manors in
the Medway valley. It is
contemporary with St Mary's
Abbey nearby, which he
also founded. The tower is
the most complete example
of his work surviving.
Malling Place, now private
accommodation, served as
a manorial meeting-place
after the Dissolution of the
Monasteries and parts of the
building have been dated to
1566.

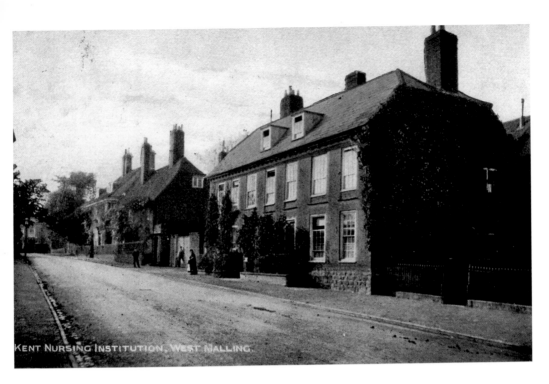

West Malling, High Street

The Nursing Institution for private nurses (since discontinued) was founded in 1875 by Lady Caroline Nevill and the vicar, the Revd John Henry Timins. The building was formed from two of the fine Georgian houses in West Malling High Street, more of which can be seen in the modern photograph. This is taken from the same spot, but facing north.

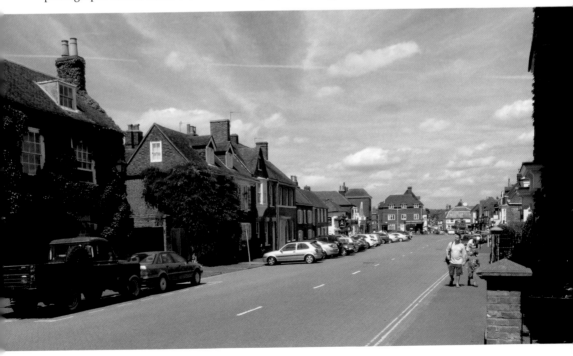

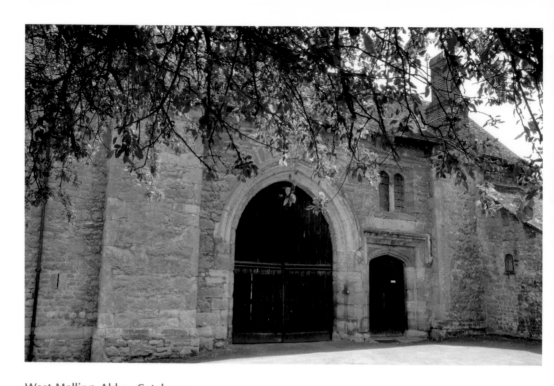

West Malling, Abbey Gatehouse
Founded by Gundulf, bishop of Rochester, in 1190, an order of Benedictine nuns returned here in 1916, having been ejected in 1538 at the Dissolution of the Monasteries. The forbidding exterior of the gatehouse hides the beautiful entrance with its little chapel (restored in the nineteenth century after having been used as a carpenter's shop.)

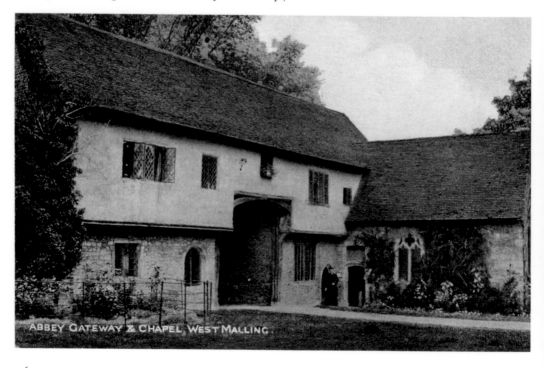

ABBEY GATEWAY & CHAPEL, WEST MALLING.

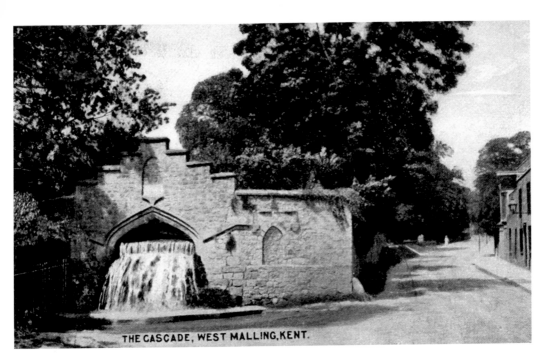

THE CASCADE, WEST MALLING, KENT.

The Cascade, West Malling

The cascade is a famous local landmark as the Ewell stream (rising at St Leonard's) leaves the Abbey grounds. As mentioned in the introduction, Hambrook joined the West Malling stationers Stedman & Co. in the early 1900s as general manager. A few cards (like this one) carry both names.

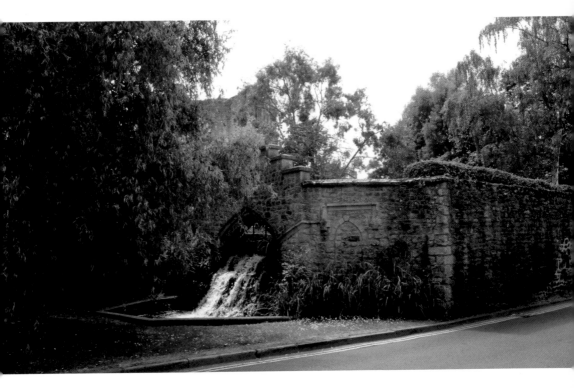

Birling Manor House

Birling Manor was built for William Nevill (1792-1845). Completed in 1838, the architect remains unknown. On the morning of 17 January 1917 a fire was discovered. Lack of local facilities and delays in summoning assistance meant the house was largely destroyed. Hambrook was ever one to capture events such as this and took a series of photographs. The ruin remained until after the Second World War, but was then demolished and today no trace exists.

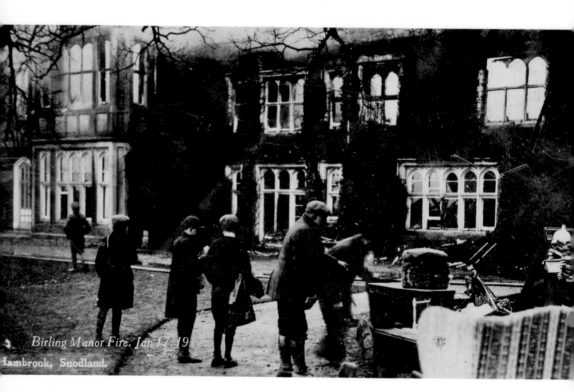

Birling Manor Fire. Jan 17, 1917

Hambrook, Snodland.

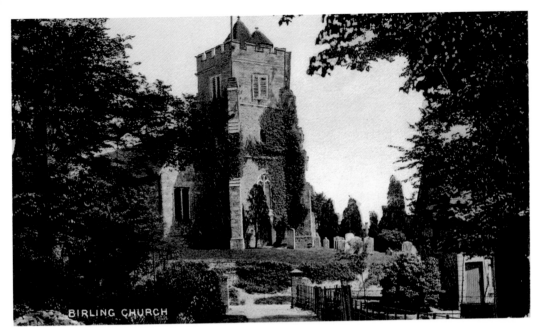

BIRLING CHURCH

Birling, All Saints Church
A view from the west rather than from the more usual south. The modern view, taken from the foot of the church tower, looks along the road to the Bull inn, with the forge on the right.

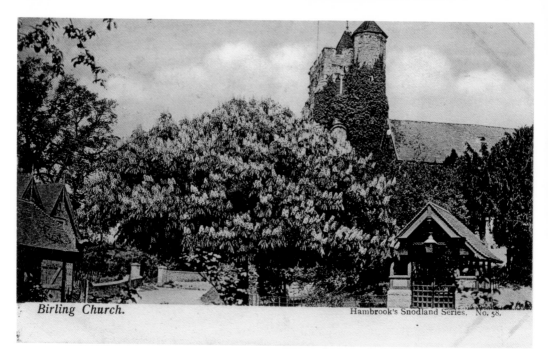

Birling Church.

Hambrook's Snodland Series. No. 58.

Birling

One of Hambrook's earliest postcards of *c.* 1904, selected rather than the better-known image which he made which is similar to the modern view. The chestnut tree in full bloom dominates the scene. The forge is on the left and the lych-gate dates from 1897 (commemorating the Diamond Jubilee of Queen Victoria).

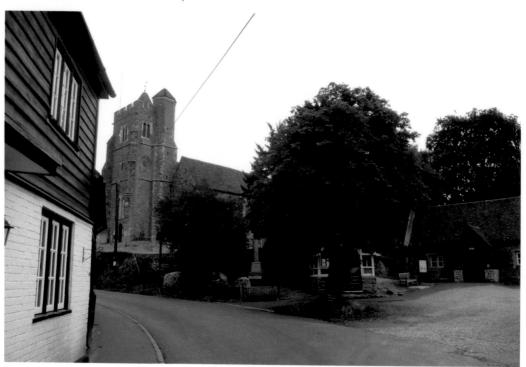

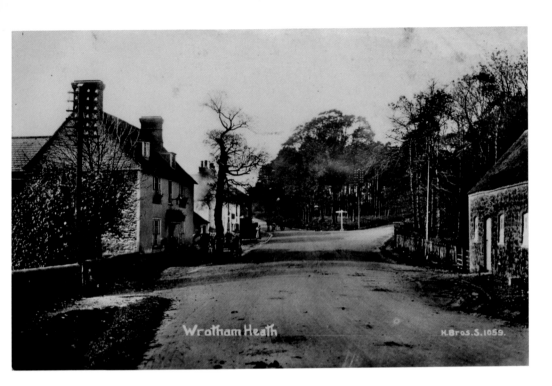

Wrotham Heath

The hamlet of Wrotham Heath grew up at the junction of what is now the A20 (to London) and the A25 (to the west) and there was a turnpike tollgate here. The old Royal Oak has been replaced by a large modern restaurant behind and the tranquillity of the early scene has vanished.

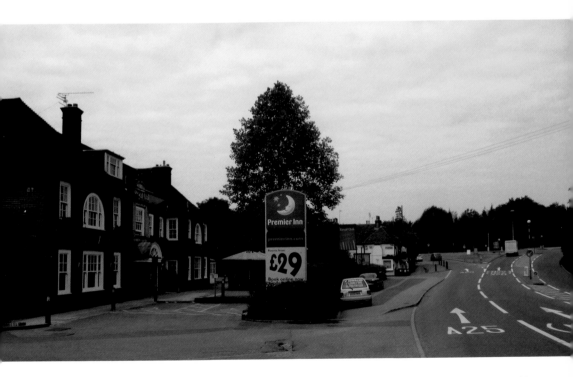

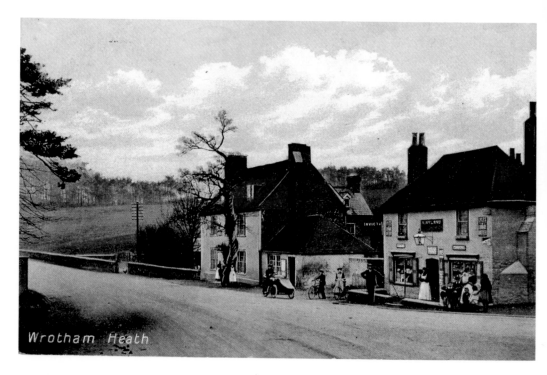

Wrotham Heath

The nearest of the buildings, once a general stores, has become a Chinese restaurant. Its structure is still recognisable, although the lack of chimneys signals central heating has been installed. By the 1920s a large garage had been built in the field and there is now a car park behind to serve the hotel attached to the new Royal Oak.

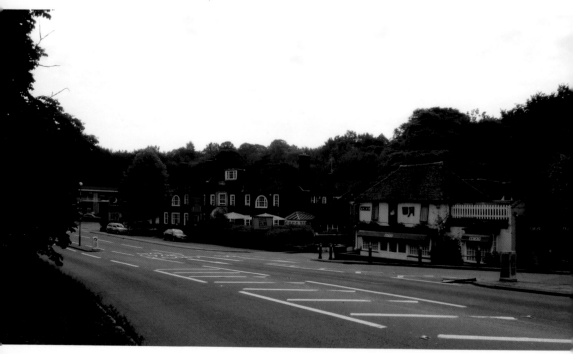

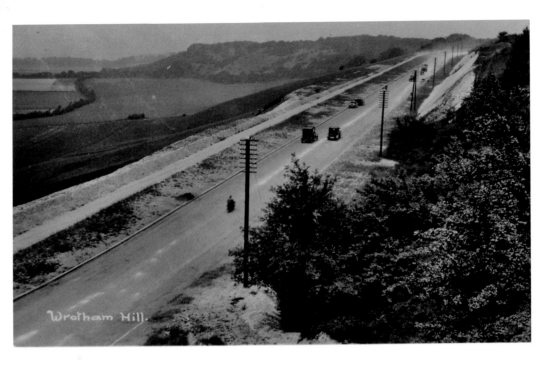

Wrotham Hill

Hambrook took several pictures of the road to London near Wrotham in 1926-7 when it was being re-built to by-pass the village. The long hill remained a challenge for early cars. Today that road still exists higher than its replacement, the M20 motorway, and is hidden on the right of the modern picture.

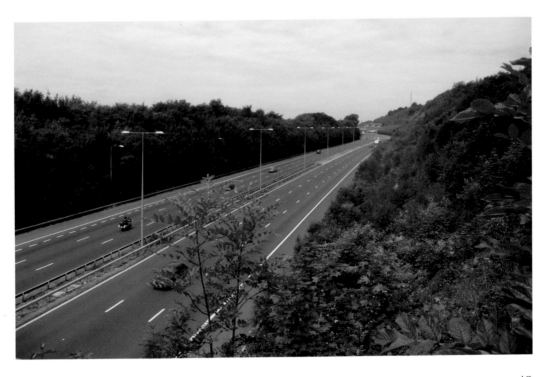

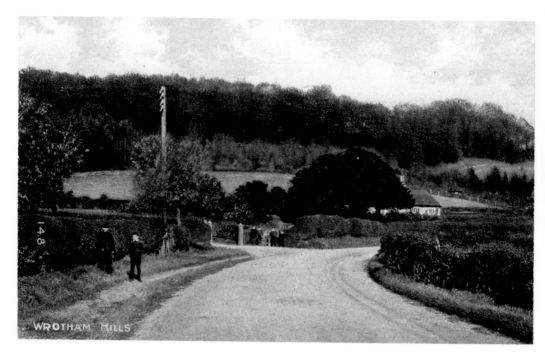

Wrotham–Gravesend Road

When Hambrook first photographed the Gravesend Road the modern A20 had not been built. Later he returned to picture the new crossroads, now converted into a roundabout, and the road to Gravesend climbs the escarpment. The modern picture is taken from the same place as the previous one of the motorway, but here facing north.

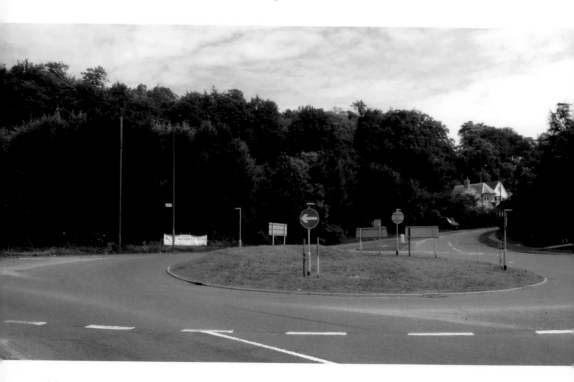

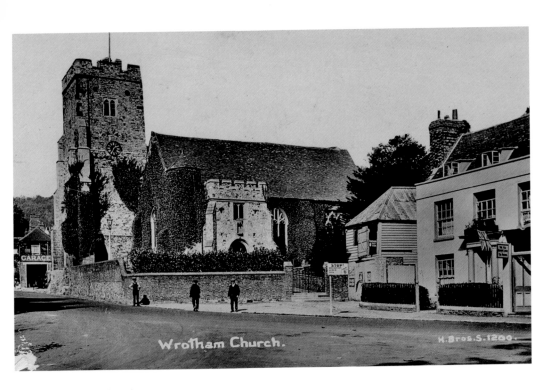

Wrotham Church

Dating from 964, this is one of the earliest churches to be dedicated to St George – before he became England's patron saint. The present building was begun in the thirteenth century. The church clock dates from 1614, again a very early example of its kind. The eight bells, re-cast in 1754, have a carillon mechanism, allowing four tunes to be played.

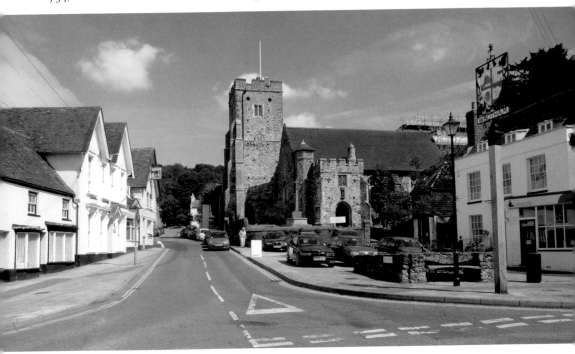

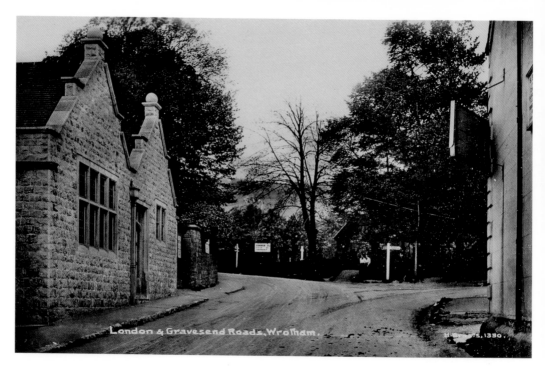

Wrotham, St George's Hall

The junction of the former roads to London and Gravesend (both now closed off), with the parish hall of St George's on the left and the cemetery immediately ahead. The attractive primary school building further down the hill served between 1868 and 1970 and has today been turned into houses.

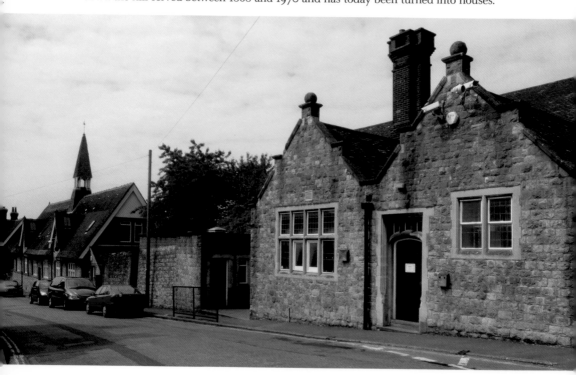

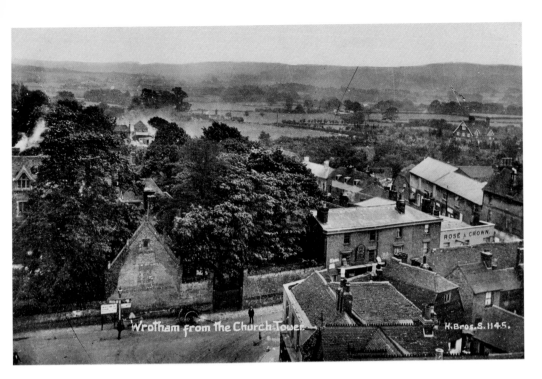

Wrotham, Looking South from the Church Tower

Part of Wrotham Place can just be seen on the left of Hambrook's picture with a secondary house (once out-buildings?) abutting the road. St Mary's Road is on the right with the Rose and Crown on the corner, one of the regular venues for the Hartley Morris Men.

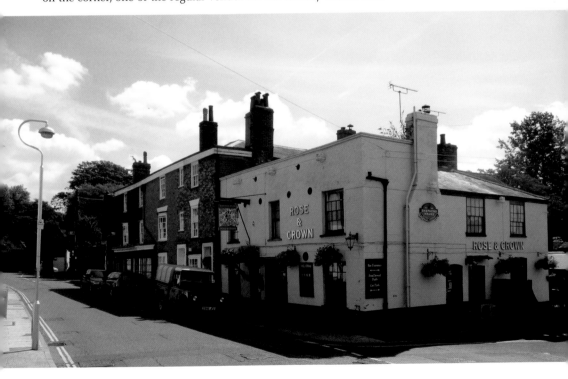

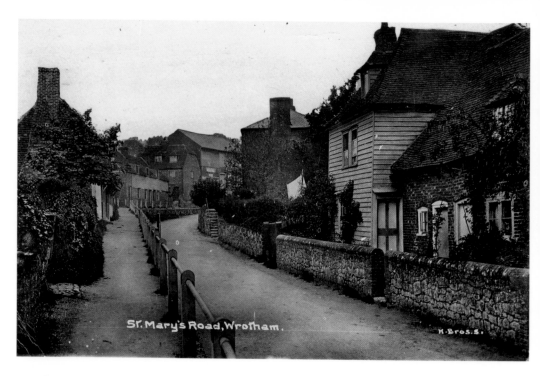

Wrotham, St Mary's Road

Hambrook took at least two photographs of the picturesque St Mary's Road, this one looking north. The modern view looks south, with a row of late seventeenth-century cottages on the right. These are among Wrotham's many listed buildings.

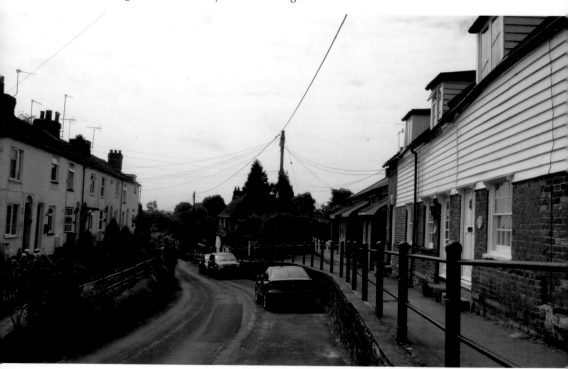

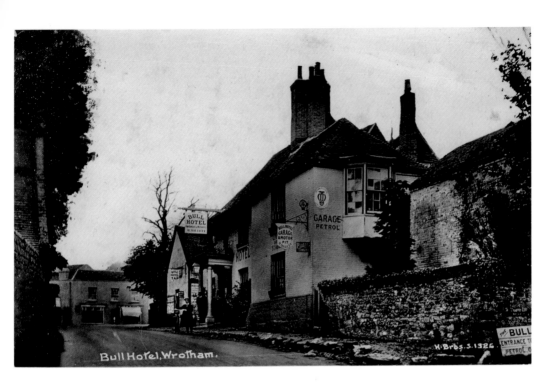

Wrotham, the Bull Hotel

The long climb up Wrotham Hill has until recently always been difficult for travellers. The Bull at Wrotham dates from the fourteenth century and was a coaching inn. But cars had begun to replace horses even a hundred years ago, as Hambrook's photograph shows.

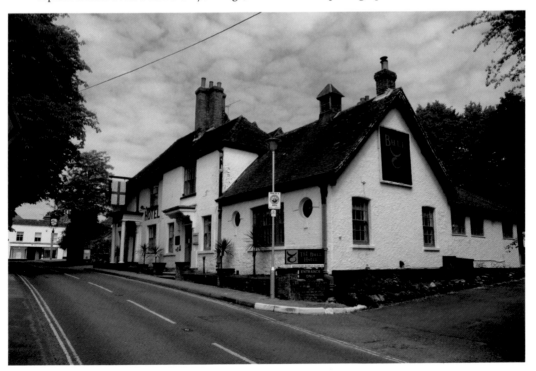

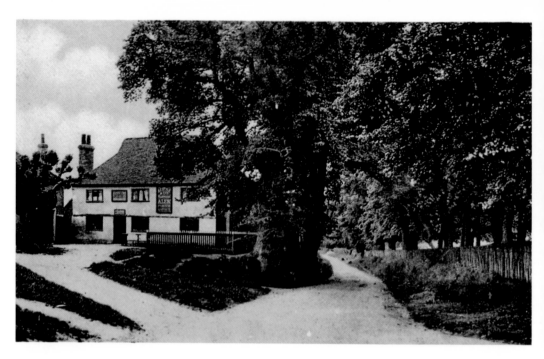

Addington Green, The Angel

Situated beside the road leading south from Trottiscliffe to Offham, Hambrook's photograph shows the fourteenth-century 'Angel' inn in about 1908. Today's view is much the same, although the building on the left now offers bed and breakfast accommodation, rather than serving as an outhouse. A wider road is essential today, so the trees have had to go.

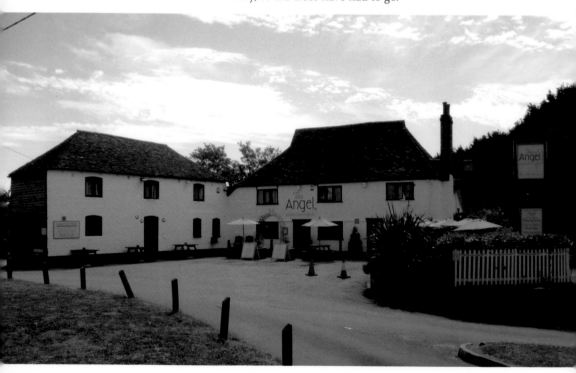

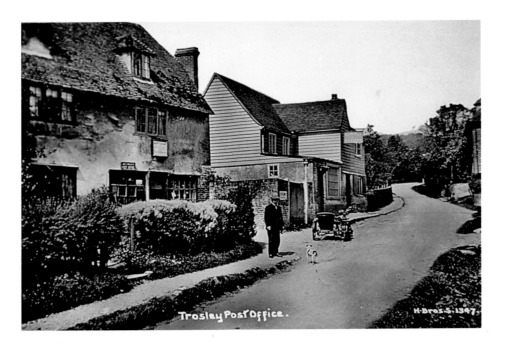

Trottiscliffe, The Street

Still conveniently named as 'The Old Post Office', the shop served for very many years as a general store selling everything from groceries to ironmongery. It closed in 1984. The weather-boarded building is now 'The Plough', but before an ale licence was granted in 1817 it comprised two fifteenth-century cottages for agricultural labourers.

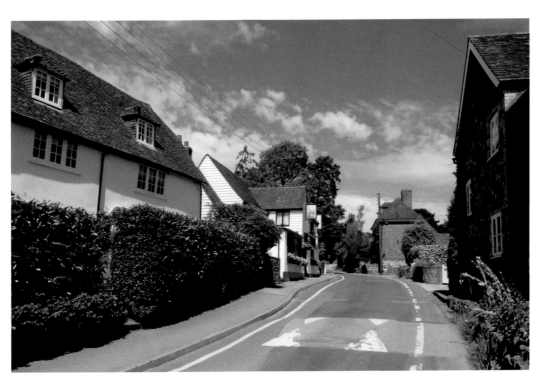

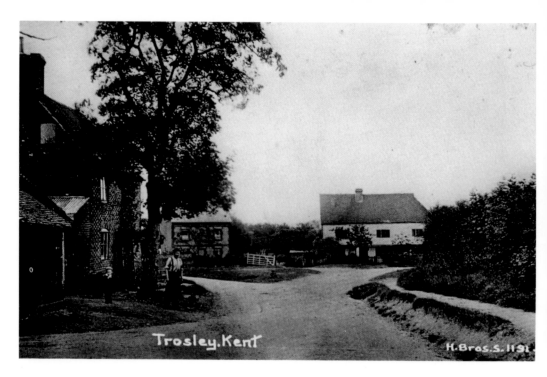

Trosley.Kent H.Bros.S.1191

Trottiscliffe, the White House

Having served as both a butcher's and then a baker's shop, the White House became the home of two famous people. First the actor Valentine Dyall lived there in the 1930s, and he was succeeded by the artist Graham Sutherland. The latter is buried in Trottiscliffe churchyard.

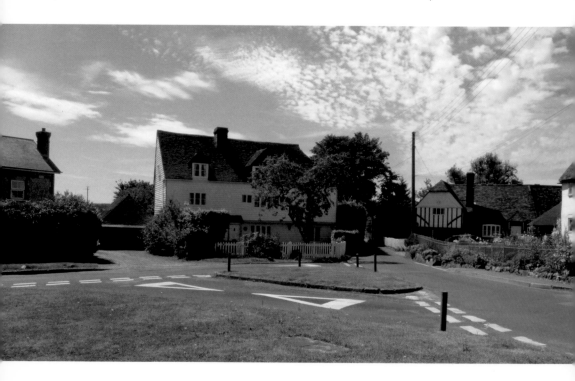

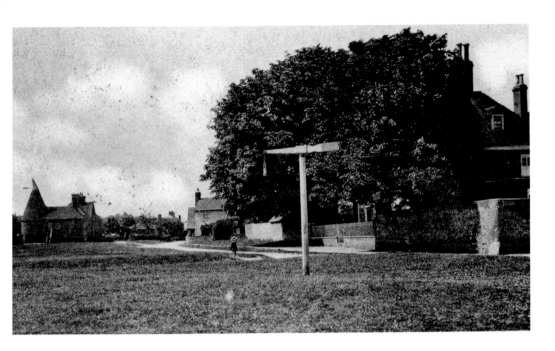

Offham, the Quintain

The Romans may have given England the pastime of tilting at the quintain, which was especially popular in Queen Elizabeth I's time. This is the last quintain post remaining in England. Horsemen would charge at the post aiming their lance at the broad end of the cross-bar. They then immediately had to duck out of the way before the other end, on which was attached a weighty bag, swung round to hit them.

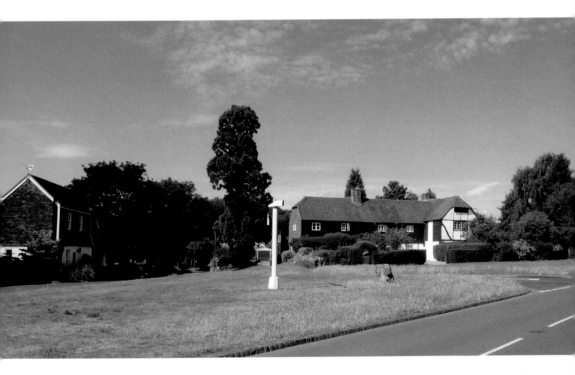

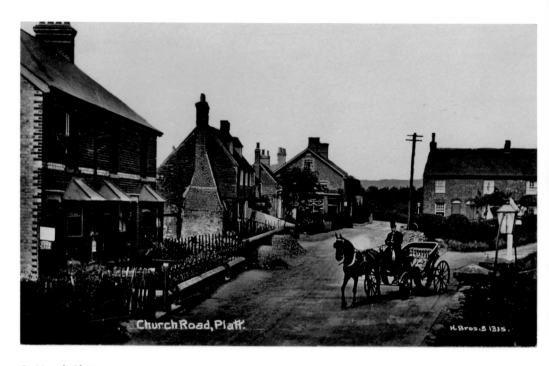

St Mary's Platt

A view north along Church Road, with the modern picture taken from the churchyard. Another Hambrook picture of the same area confirms that the two mounds in the road are piles of flints for road repairs.

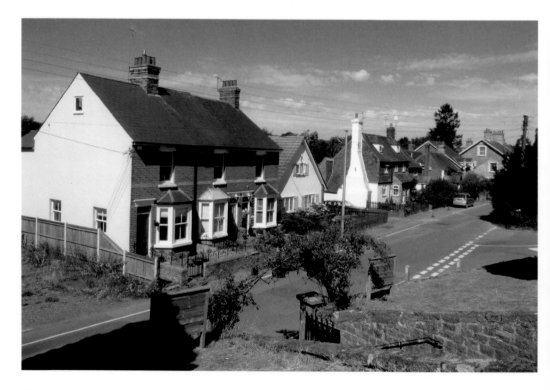

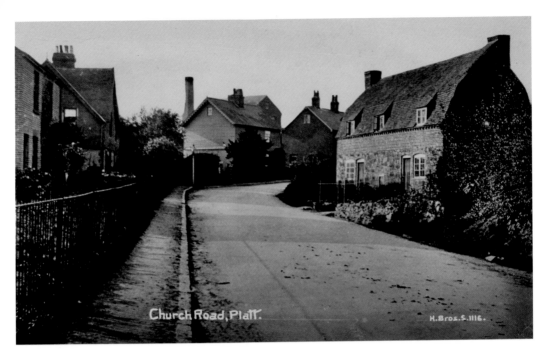

Church Road, Platt. H.Bros.S.1116.

St Mary's Platt, Church Road

Some two hundred yards further north from the previous picture shows more of the attractive old houses in the road. It is interesting to note that the small original windows in the former pair of houses on the right have been replaced by larger ones; evidently we expect or need more light in our houses today.

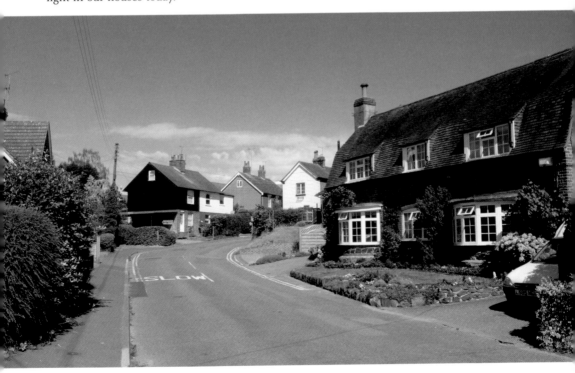

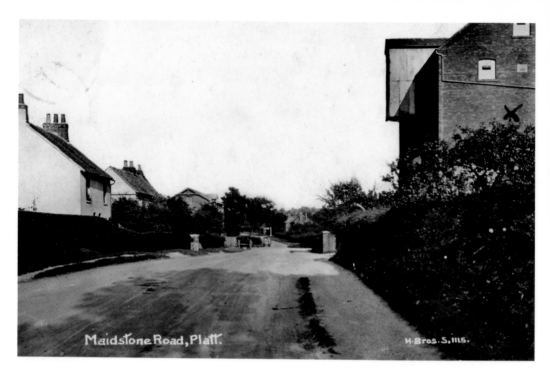

Maidstone Road, Platt.

H.Bros.S.1115.

St Mary's Platt

The mill building on the main road to Borough Green is still a familiar landmark. In Hambrook's day and until relatively recently it was the Platt Flour Mills, but now its use has diversified to incorporate both housing and offices. The once empty road is now the busy A25 and there is a plea for a by-pass.

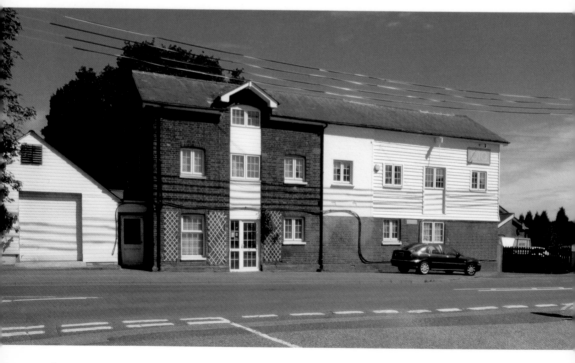

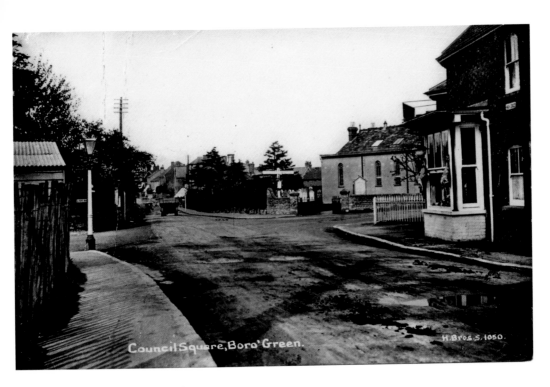

Borough Green, Crossroads

The view north along the High Street, with the A25 passing across the picture. On the right the Baptist Chapel had been built in 1817. It has since been enlarged twice and a school room added. Several other changes can be seen to the buildings bordering what was called Council Square.

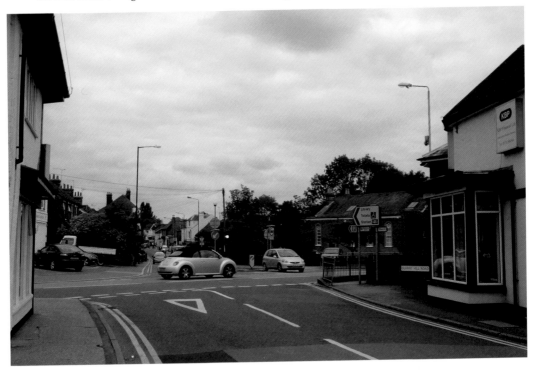

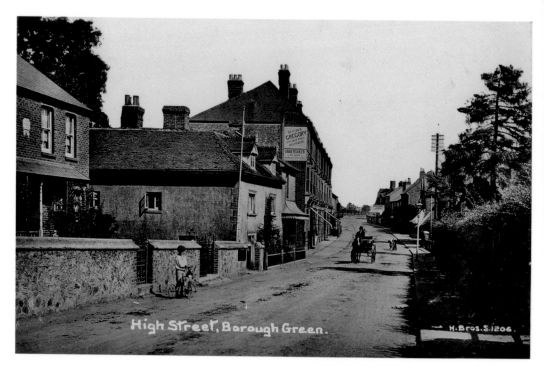

Borough Green, High Street
A view looking north with the end of the churchyard on the right. The low house opposite was formerly the farmhouse of Yew Tree Farm, 56 acres of whose land was sold for building in 1877. This contributed immensely to the development of the village, including Western Road.

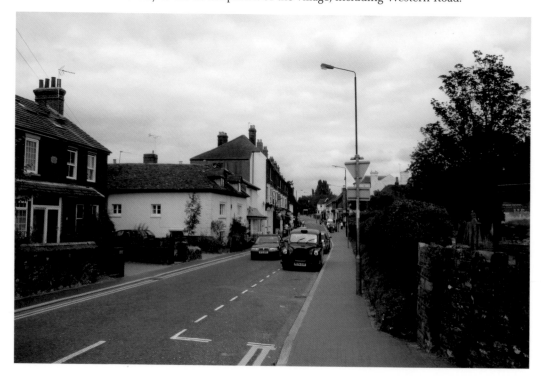

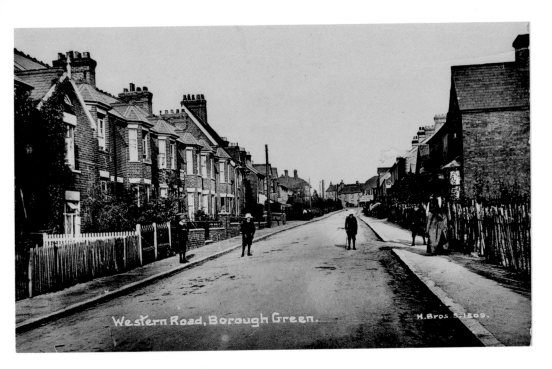

Borough Green, Western Road

Today Western Road forms the preferred route for those travelling between the M20 and Wrotham and Sevenoaks and Tonbridge. It was part of the large development of 1877 planned for land formerly belonging to Yew Tree Farm. Most of the houses in the road were built by 1900.

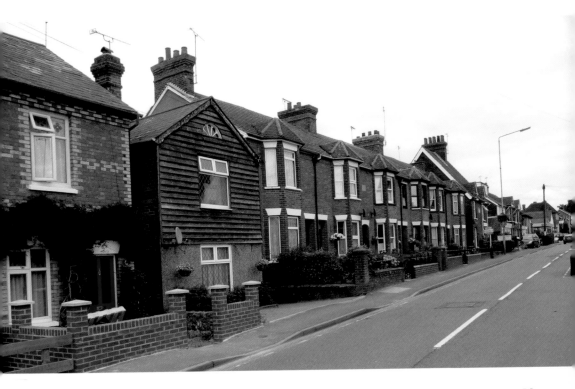

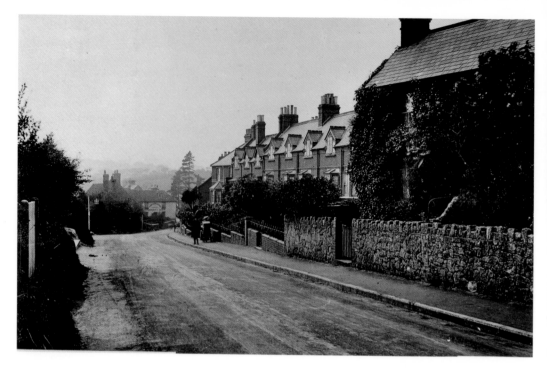

Borough Green, Sevenoaks Road
The attractive row of houses called 'Sunnyside' in Sevenoaks Road. The cream building in the distance (on the left) is the Red Lion, formerly called the White Bear, recorded as early as the 1500s. Today it is a listed building, part of which dates from the seventeenth century, but was boarded up when this photograph was taken.

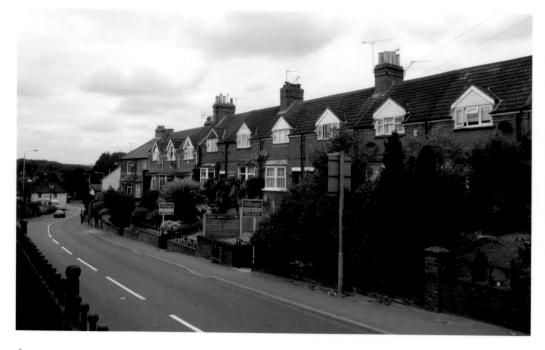

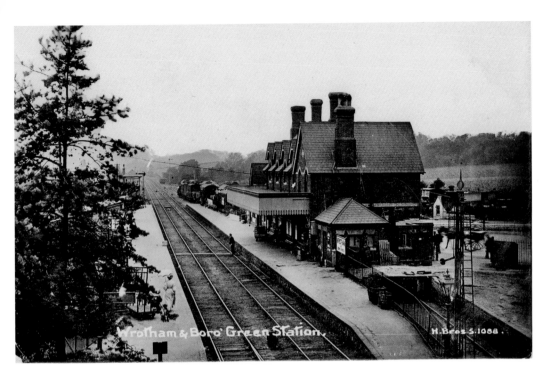

Wrotham and Borough Green Railway Station
Hambrook took a number of station photographs. The line from Otford to Maidstone was opened in 1874 and made into double track in 1882. The original 1874 station building is the single-storey structure largely hidden by the canopy and it is believed that the main building was built when the double track was laid. The same thing happened at West Malling, which is almost identical.

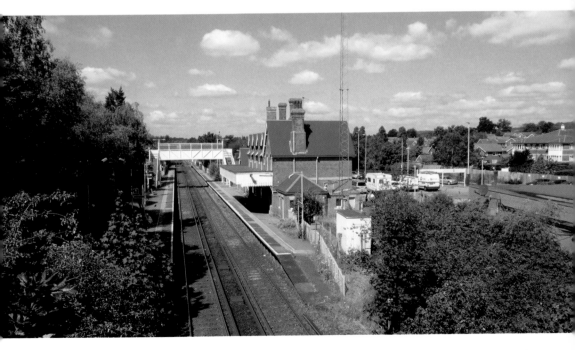

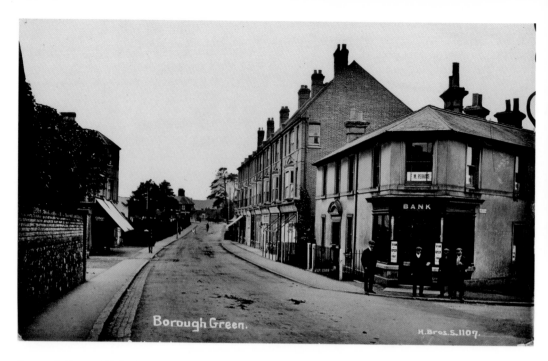

Borough Green, High Street

A view of the High Street looking south from the junction with Western Road. 'M. Perkins', a printer, places the picture before 1914 and the row of three-storey buildings behind dates it from after 1908. At that time the bank opened only on Fridays. The building, built in the 1880s, had previously served as a baker's, but remains a bank today.

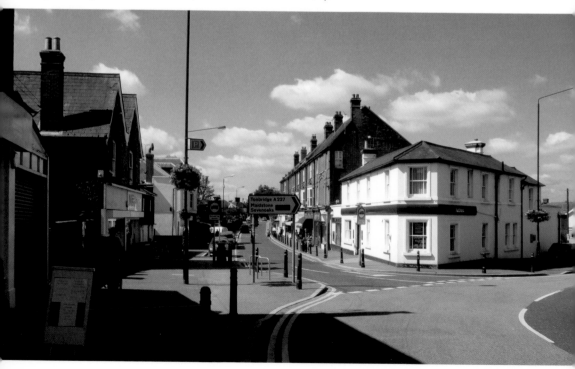

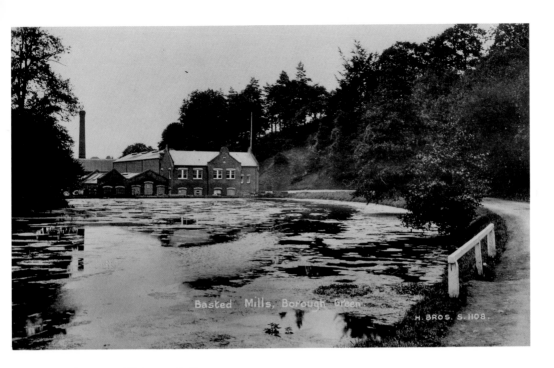

Basted Paper Mill, Borough Green

The paper mill at Basted was well established by the mid nineteenth century and had five beating engines working in 1851; forty-eight people worked there in 1891. Today the spot is a delightful wildlife and picnic area, while a surviving part of the mill and its surrounds has been made into housing.

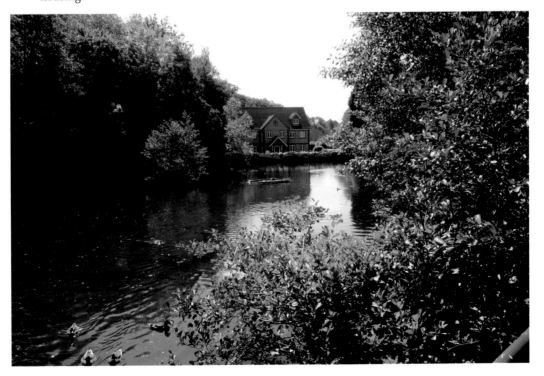

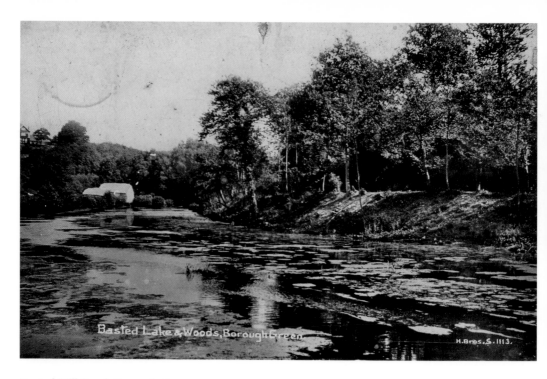

Basted Lake & Woods, Borough Green

H.Bros.S.1113.

Basted Mill Pond, Borough Green
The mill pond looking north (from the papermill end) was apparently as tranquil in Hambrook's day as it is now. A wide variety of aquatic birds has been encouraged to make their home here to increase the attraction for visitors.

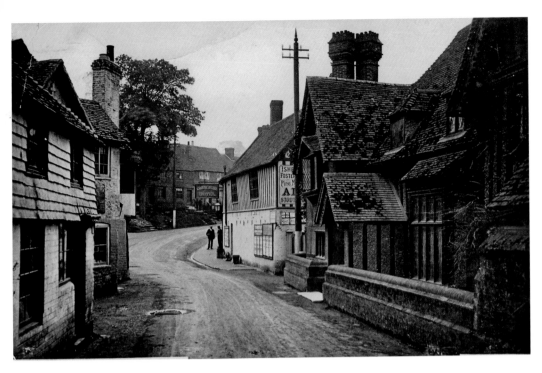

Ightham, Town House
The fine 'Town House' on the right is believed to have replaced an earlier tenement on the site. The present building has the date '1587' carved over a window and is a fine example of a Wealden hall house with additions. The weather-boarded building on the left was pulled down around 1930.

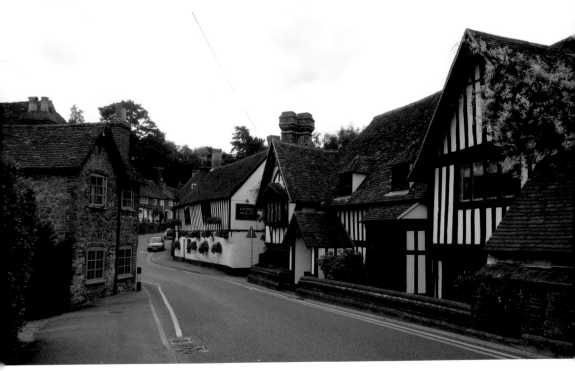

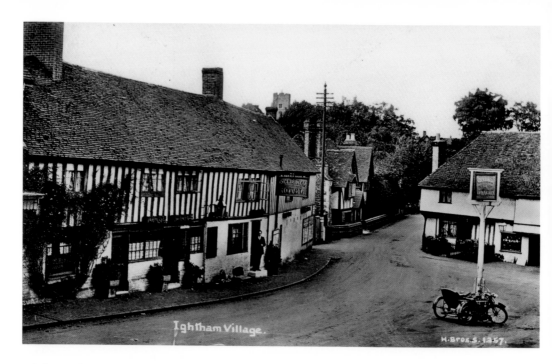

Ightham, The George and Dragon

This is the oldest of the present buildings in Ightham, with a date of '1515' carved in an upper room. The inn also served as the meeting place for the Manor of Ightham, certainly from the seventeenth century, and probably before. A tradesman's token of about 1669 is known for 'Henry Greene. His Halfpenny George and the Dragon'.

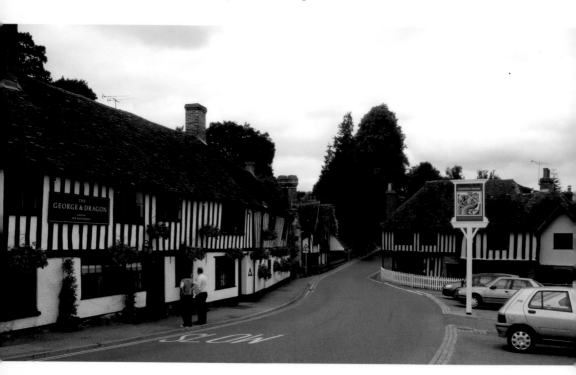

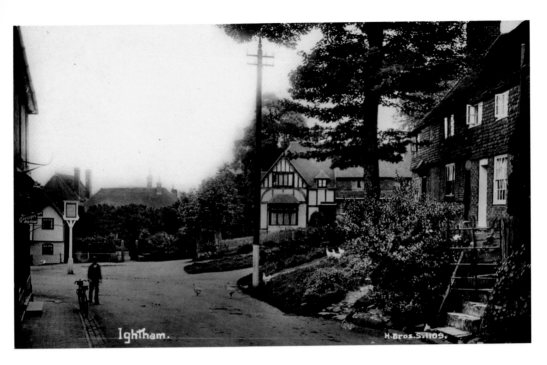

Ightham, Skynner's House
Thomas Skynner was fined in 1555 for encroaching on the highway after building this house, so giving us a date for it. Running west up the street from Skynner's House the second and third houses in 'The Bank' were known as the 'Spread Eagle' in 1710.

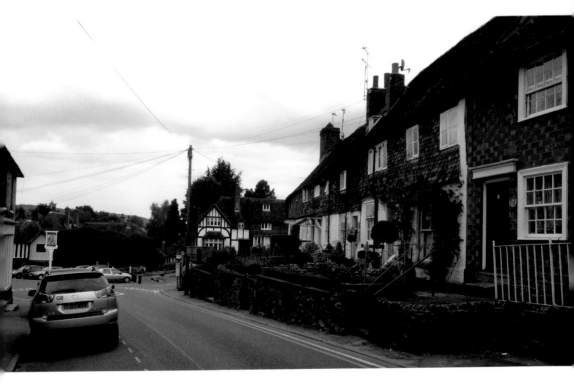

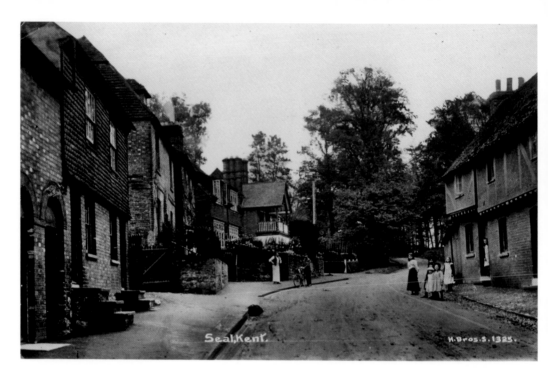

Seal, High Street

The steep climb out of the village towards Crown Point and Ightham. Many of the old buildings lining the High Street are listed, including some of these. Neither the photographer nor his audience would dare stand in the road today.

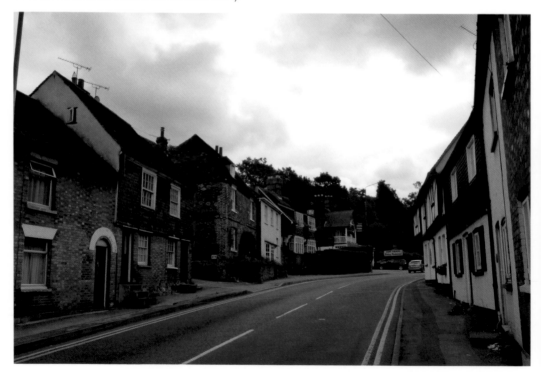

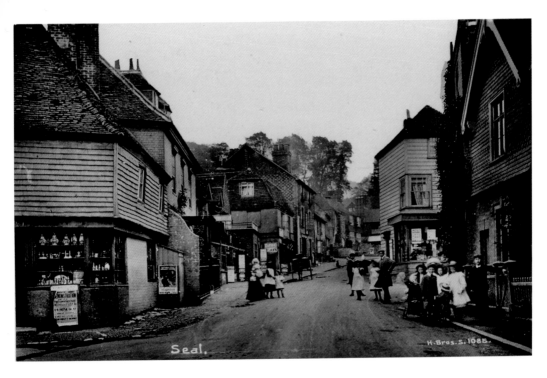

Seal, Church Street

More perilously placed spectators further down the hill! Hambrook seems to have had a good audience for all his work in Seal. Church Street joins from the left, with the Crown inn opposite.

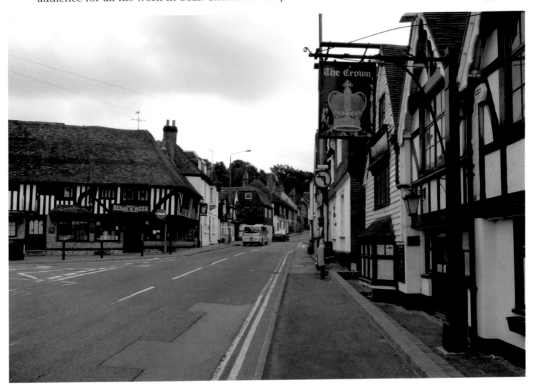

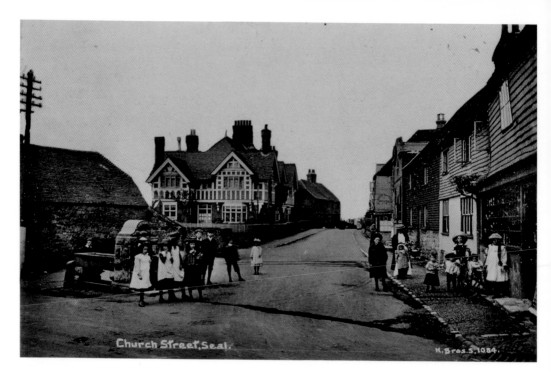

Church Street, Seal.

K. Bros. S. 1084.

Seal, Horse Trough

Looking north at the entrance to Church Street the buildings all survive, although the mock-Tudor beams are modern. The horse trough on the left was no doubt very welcome for horses about to climb the steep hill towards Ightham. No longer required for them, it has been moved and filled with flowers.

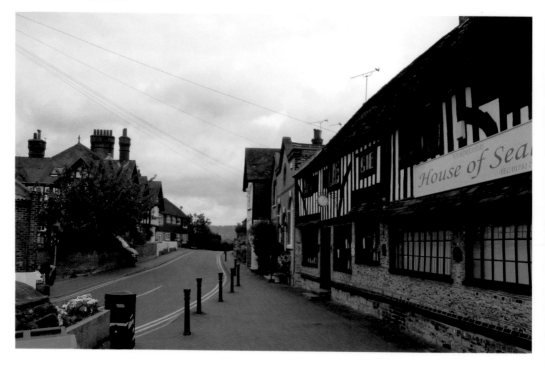

House of Sea

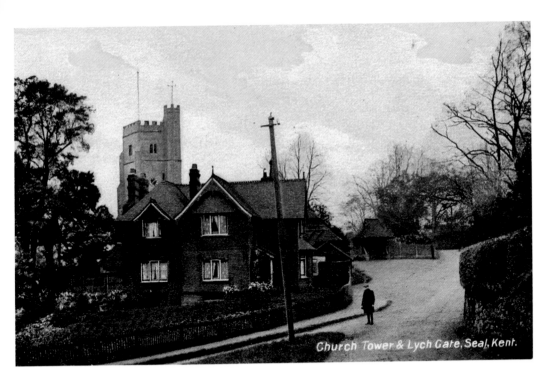

Church Tower & Lych Gate, Seal, Kent.

Seal, Church of St Peter and St Paul
The core of the church of St Peter and St Paul dates from the thirteenth century, with many later additions, including the fine tower built *c.* 1520-9. Due to its elevated position this is clearly visible from the countryside around.

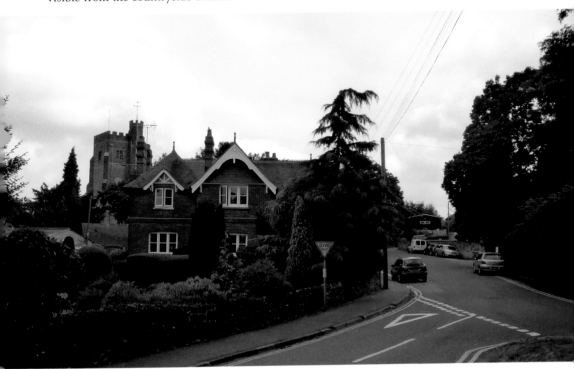

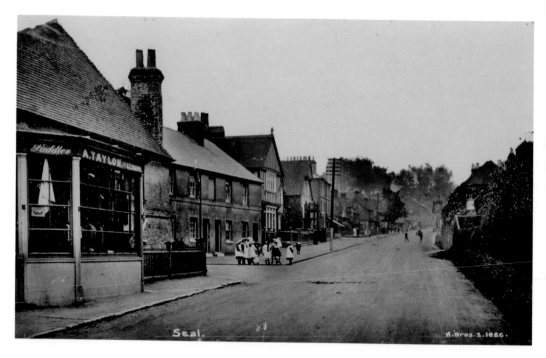

Seal, High Street

A view along the High Street looking up the hill towards the east. Taylor's shop has been replaced by a new library, bringing the houses beyond into greater prominence. The children in Hambrook's picture may have come from the village school since School Lane leads off to the left here.

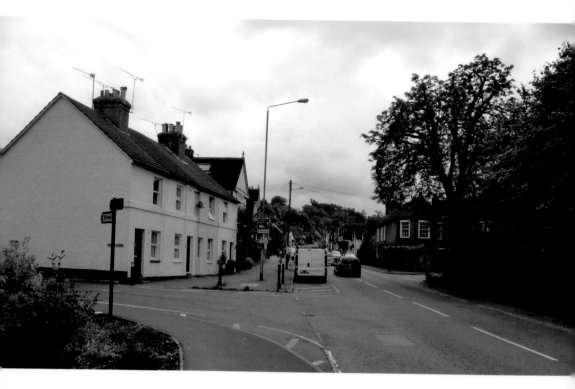

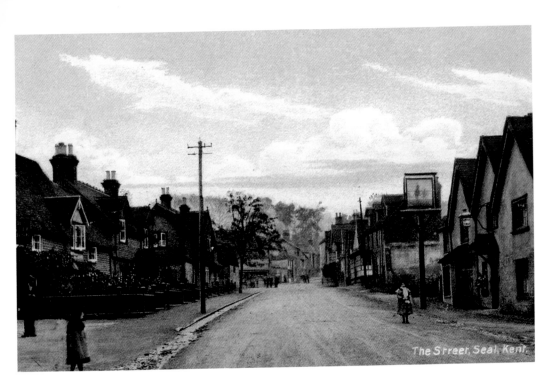

The Street, Seal, Kent.

Seal, Kentish Yeoman

Hambrook's view is again looking east up the hill, where the modern picture looks west towards Sevenoaks from the same point. The pub is currently called the Kentish Yeoman, but was empty at the time of the photograph. A number of modern shops have sprung up on the north side.

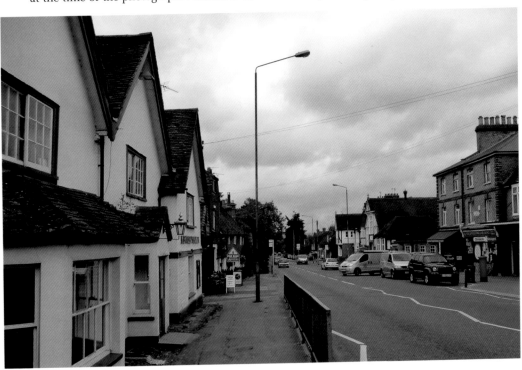

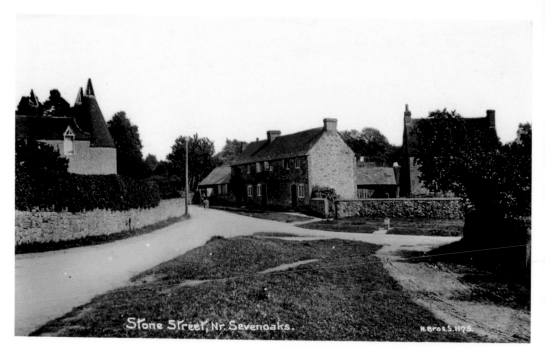

Stone Street

Were it not for the three oast houses and confirmation from early maps, it would have been impossible to match these two scenes. The old houses have been swept away to be replaced by modern properties and the road has been re-aligned.

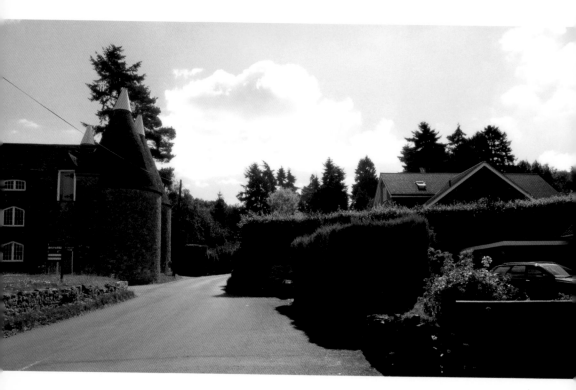

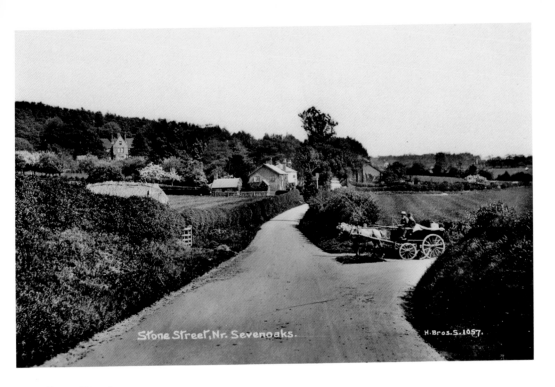

Stone Street

It has proved very difficult to match old and modern pictures of Stone Street, but the only T-junction identifies this site. Everywhere today there is so much extra foliage that one can only assume that there were once plentiful agricultural labourers to keep it all in trim.

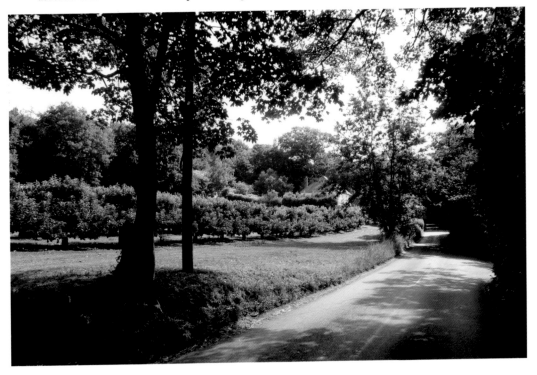

Stone Street

The pond proved easy to find. More can be seen in the old picture than the new, since extra foliage hides the house, while a large industrial or farm building fills the distant view.

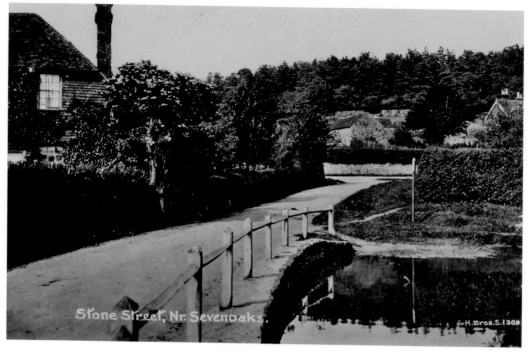

Stone Street, Nr. Sevenoaks.

H.Bros.S.1309

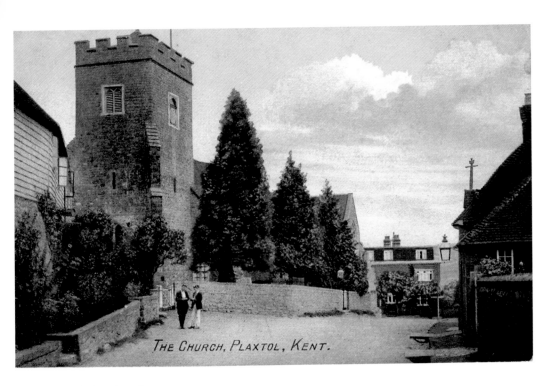

THE CHURCH, PLAXTOL, KENT.

Plaxtol, the Church

The view east down Plaxtol Lane has changed hardly at all in the hundred years since Hambrook made his postcard. The church was built in 1649, and enlarged during the nineteenth century, but experts believe it possible that some features may have been salvaged from an earlier building on the site. Because it was created in the Cromwellian period, it has no dedication.

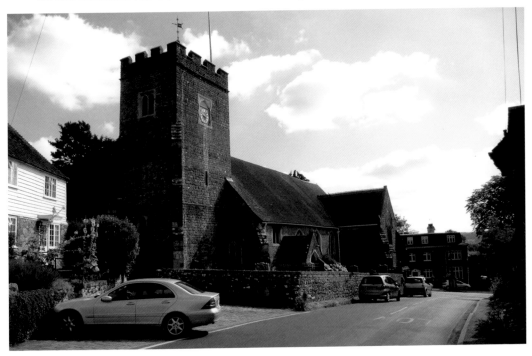

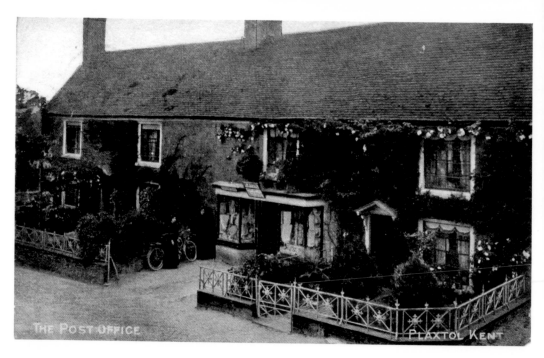

Plaxtol

Now 'The Old Post Office', because it has been replaced by a newer one further down the street, this attractive pair of eighteenth-century houses still retains a bay window where the shop once was. Part of the fine seventeenth-/eighteenth-century row of seven weather-boarded houses called Church Row can be seen beyond.

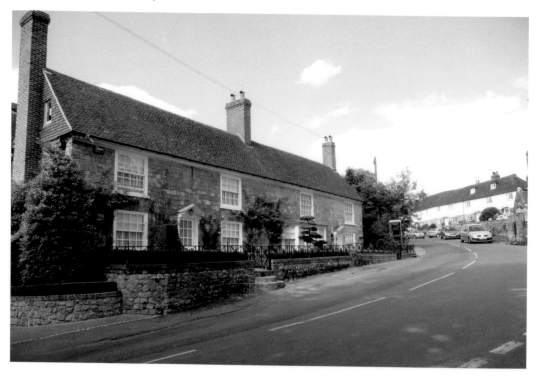

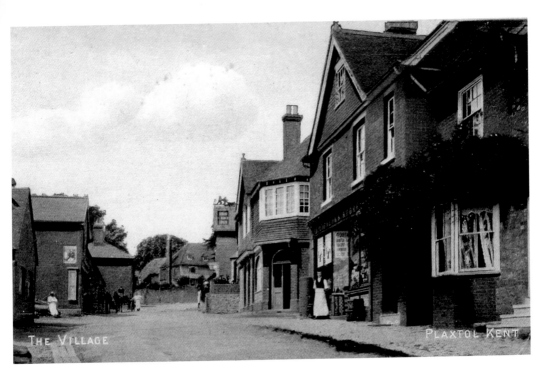

Plaxtol, The Street

The modern way of life has cluttered up The Street today, compared with Hambrook's view of a hundred years ago. A few shops are here, including the present post office which can just be seen on the right.

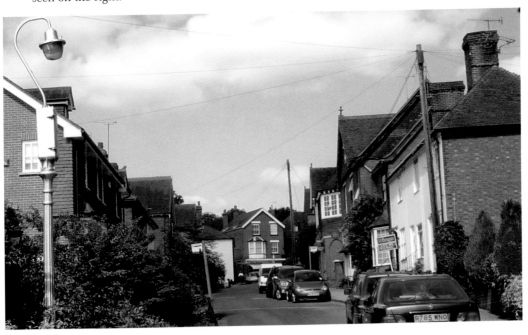

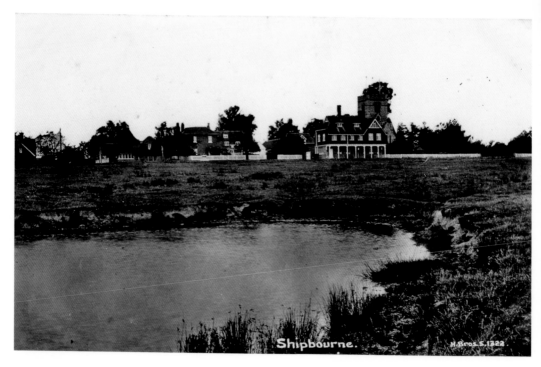

Shipbourne

Hambrook issued two very similar pictures from the green looking west towards the church of St Giles and the pub, which dates from *c.* 1881. Now the pond is nowhere to be seen on this fine open public space.

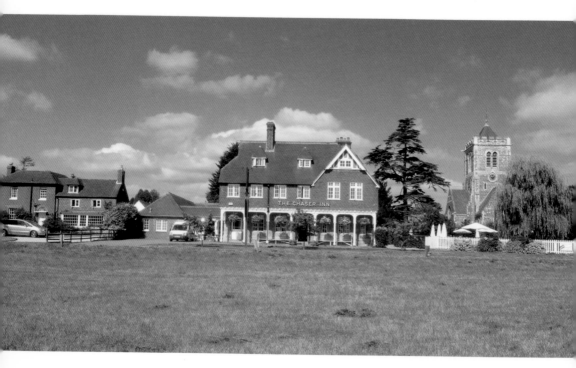

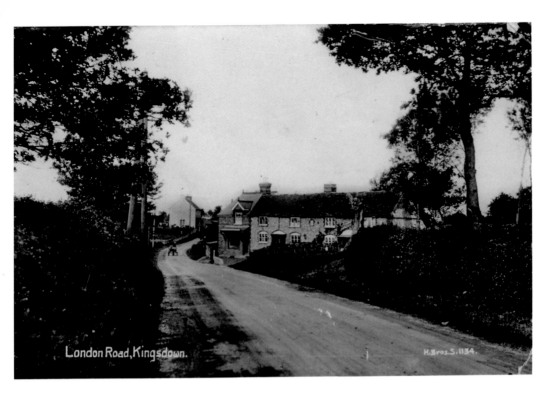

London Road, Kingsdown.

H.Bros.S.1134.

West Kingsdown

Hambrook's view of the London Road was taken before the A20 was widened (several times). Before the M20 was built the road took all the heavy traffic and, with Brands Hatch nearby, required a dual carriageway here. The old houses stood in the way and today the buildings here are largely from the twentieth century.

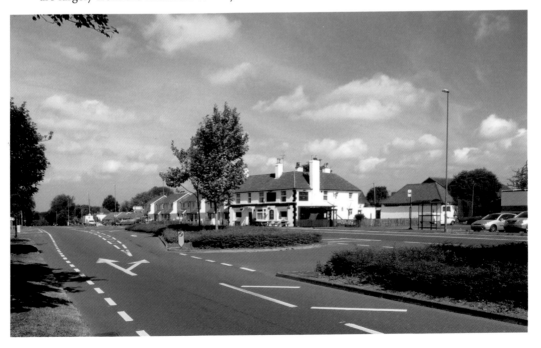

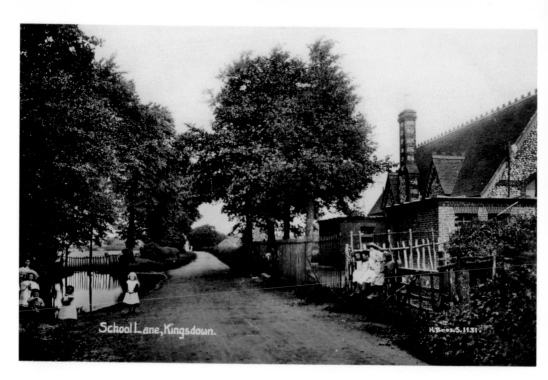

West Kingsdown

A pastoral scene early in the twentieth century with schoolchildren outside their school. The education of today's pupils is in a new building elsewhere. Their pond which was so freely accessible is now protected by a metal fence and is a shadow of its former self.

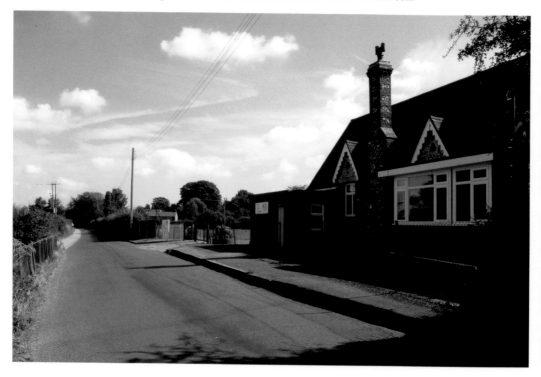

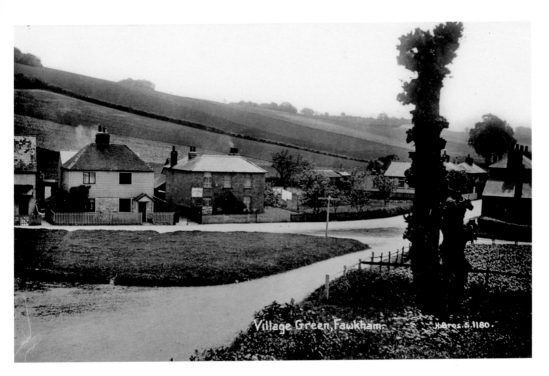

Fawkham Green

The centre of the village with the little village green in the foreground. The war memorial is now placed here and trees have been added. The modern picture faces in the opposite direction towards the Rising Sun, which incorporates features dating from the sixteenth century.

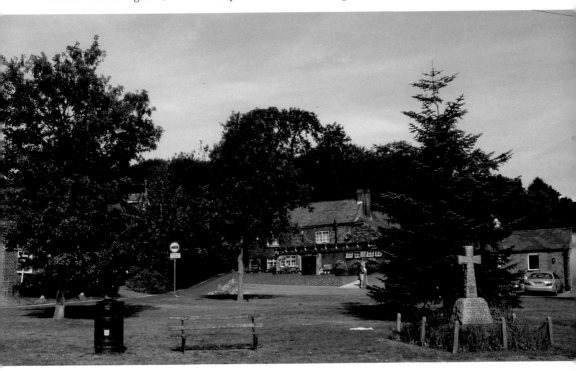

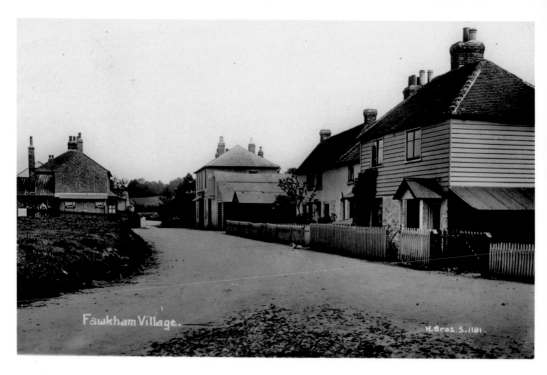

Fawkham Green

Some of the old houses lining the road towards Longfield in Hambrook's picture have been replaced by new ones, and some have been modernised, but the variety of styles remains attractive. The road to Fawkham runs off to the right.

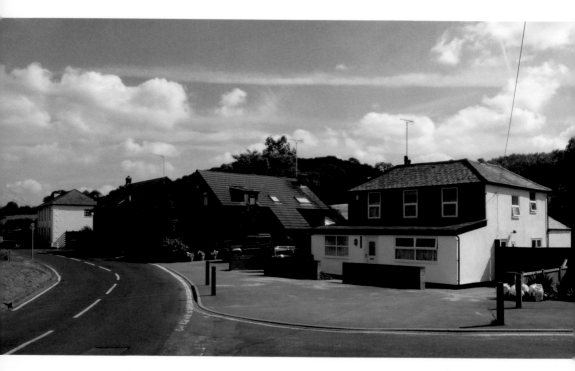

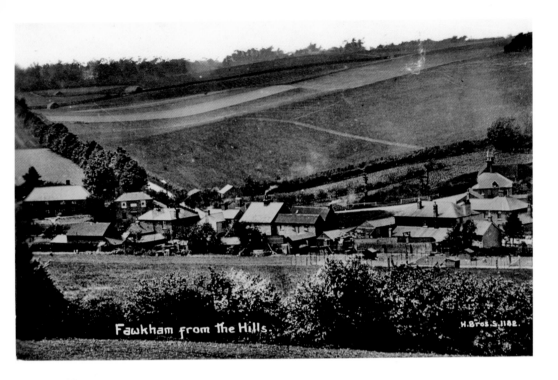

Fawkham from the Hills.

Fawkham Green

Hills surround the centre of the village, but today there seem to be no places from which to match the clear view of the old picture. This group of houses bounding the road to Longfield was photographed from St Michael's Lane.

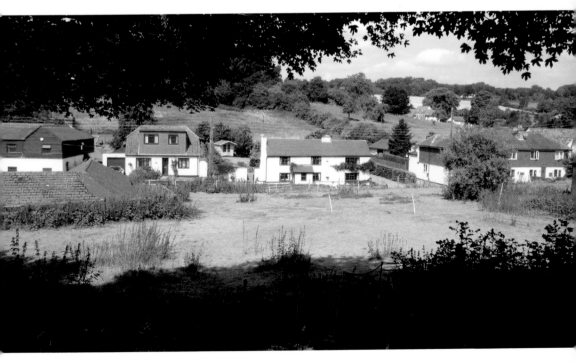

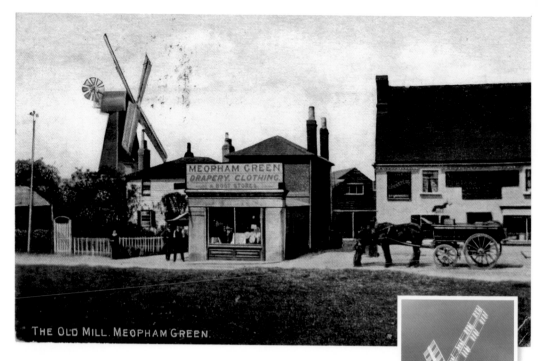

THE OLD MILL. MEOPHAM GREEN.

Meopham Green

The smock windmill was built in 1801 and remained as a working mill until 1965. In recent years the parish council has restored it and uses it for its headquarters. On the right of Hambrook's picture is 'The Cricketers' which, as the modern photograph shows, has lost its historic name. Meopham Cricket Club was officially founded in 1776 and is one of the oldest clubs in the county.

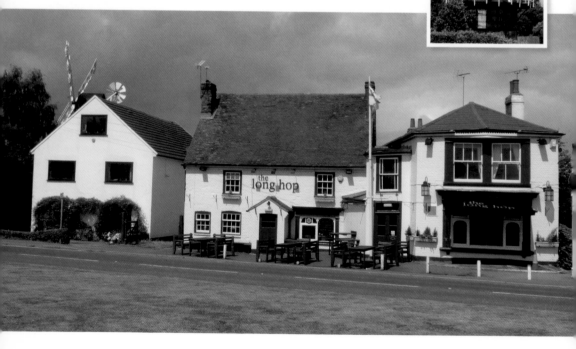

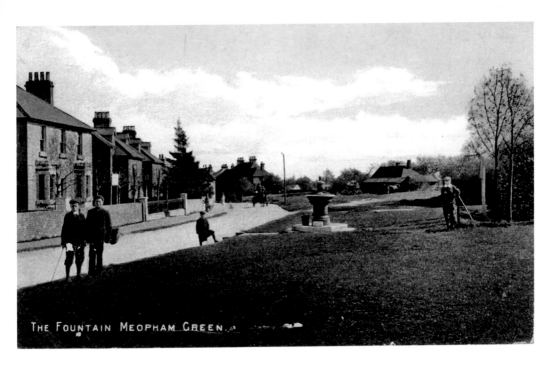

THE FOUNTAIN MEOPHAM GREEN.

Meopham Green
The ancient and lovely triangular cricket green, a public open space, is maintained by Meopham Cricket Club. The drinking fountain was erected to commemorate the coronation of Edward VII and Queen Alexandra on 9 August 1902. Money for it was raised by a grant from the Metropolitan Drinking Fountain Association with local subscriptions.

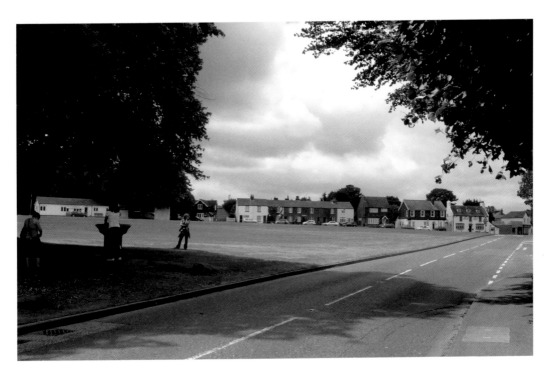

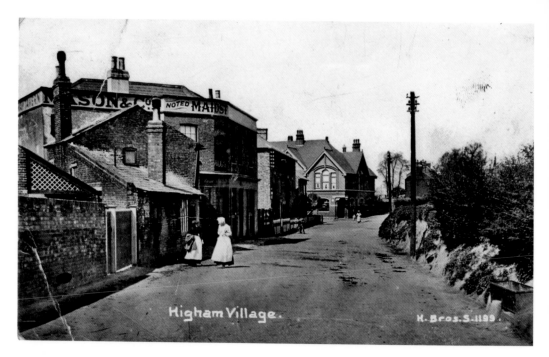

Higham

This small group of buildings must in part have been created to serve those using the nearby railway. The Railway Tavern looks prosperous, but the Chequers in the distance was boarded up when the modern picture was taken. It is unusual to find a three-storey terrace of houses between them, Brooker's Place dated 1856.

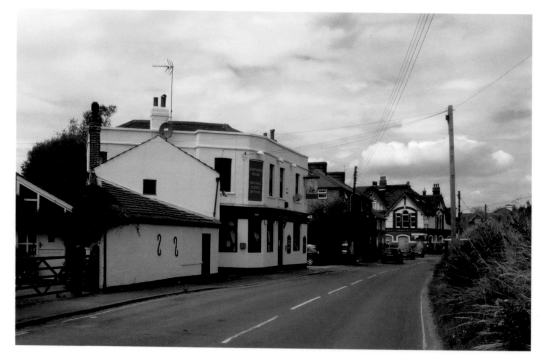

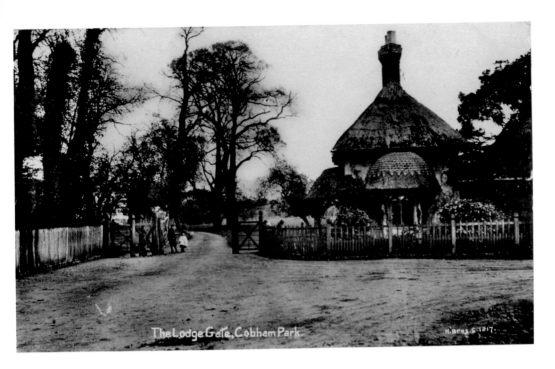

The Lodge Gate, Cobham Park.

Cobham

The Lodge Gate on the Cobham Hall estate with farm nearby and the route through to the great house beside it. Somehow the immaculate and tidy roof seems somewhat unreal, although it is undoubtedly a tribute to the work of modern thatchers. It is good to see the thatch patterns still echo those in Hambrook's picture.

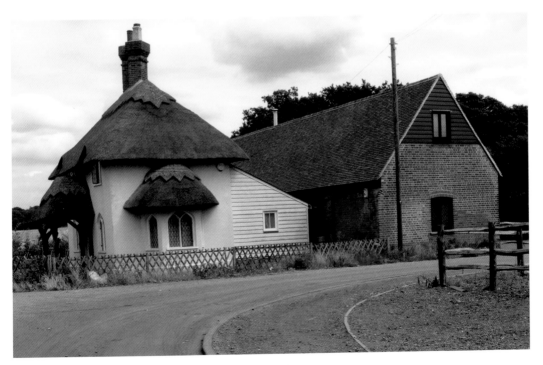

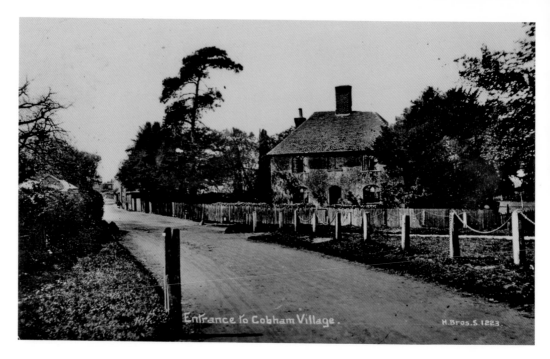

Cobham

Rose Cottage stands at the east end of the village. Hambrook's picture is taken from the end of the roadway to the Lodge Gate looking down The Street towards the village. The modern picture is further to the right and shows more of the crossroads here: to Cuxton on the left and towards the A2 on the right.

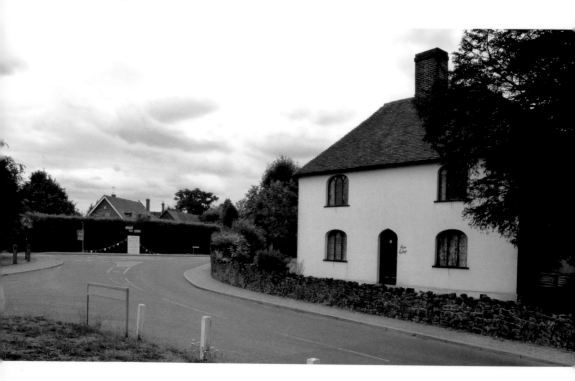

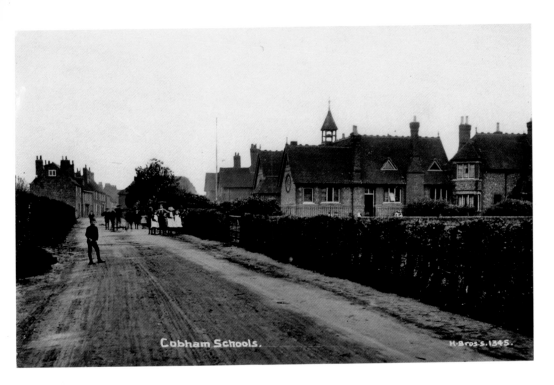

Cobham, the School
The attractive village primary school was built in 1874 to a design by T. M. Wyatt and was given to the village by the Earls of Darnley. The original building is listed, but a new portion has been added on the east side.

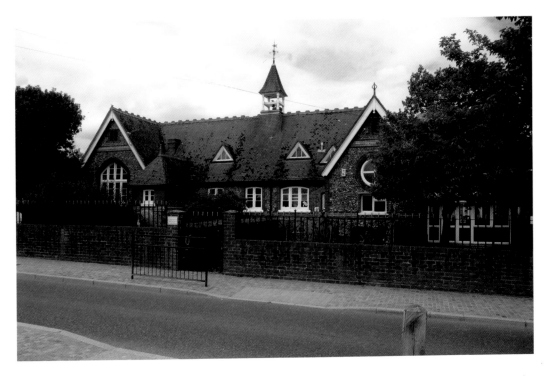

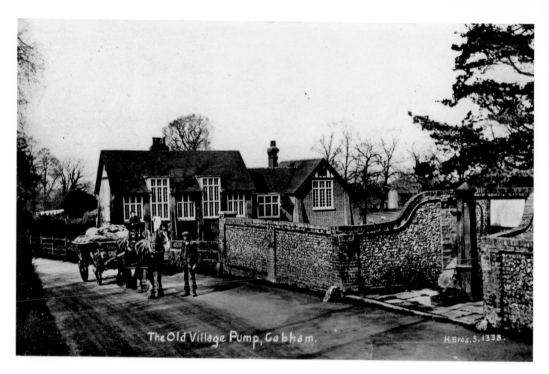

The Old Village Pump, Cobham.

H.Bros.S.1338.

Cobham, the Old Village Pump
A tablet in the wall behind records that the octagonal iron pump (Grade II listed) was rebuilt by the Earl of Darnley in 1848. Hambrook's picture also shows the attractive village hall, the 'Meadow Room', built in 1898, but trees now obscure a similar view.

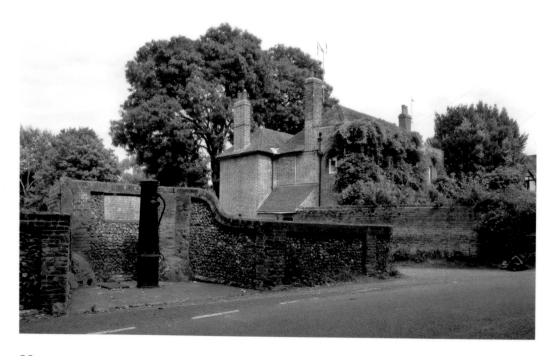

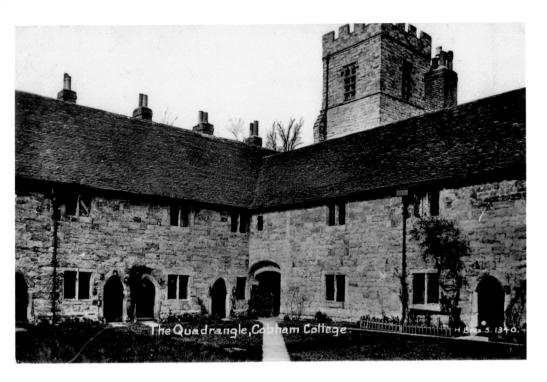

The Quadrangle, Cobham College.

Cobham, the New College

In 1362 Sir John de Cobham founded a college to say masses for the souls of his ancestors. That scheme foundered at the Dissolution of the Monasteries and in 1598 the buildings were adapted to provide twenty almshouses and have been used as such ever since. The inhabitants were to be chosen from Cobham and a number of neighbouring parishes.

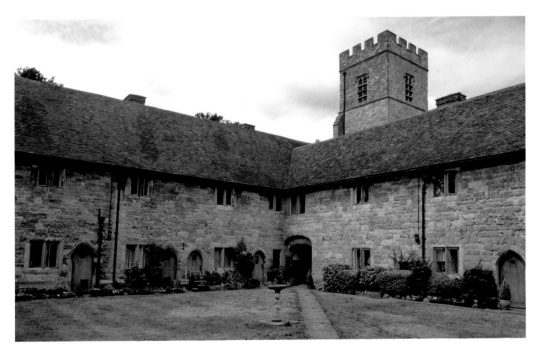

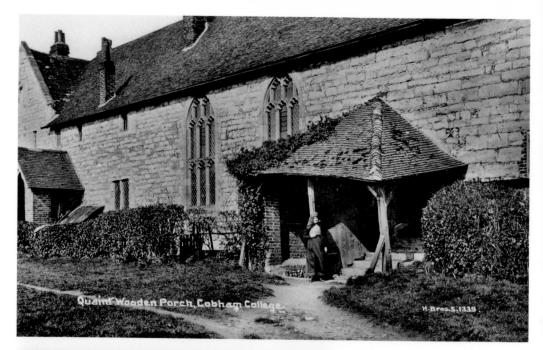

Quaint Wooden Porch, Cobham College.

H. Bros. S. 1339.

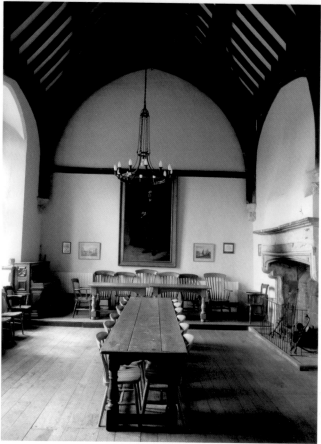

Cobham, the New College
The south side of the New College with its misshapen porch. The wall behind is the exterior of the fine college hall, which was part of the original fourteenth-century buildings. The interior roof beams and fireplace are also of this date.

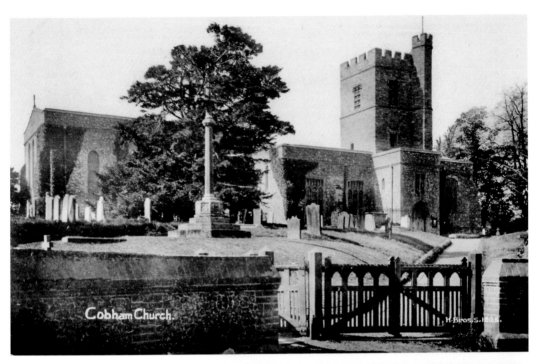

Cobham Church.

Cobham, Church of St Mary Magdalene

Many photographers have taken this view of Cobham church from the road. The fabric of the present building dates from the thirteenth century and the chancel houses a magnificent series of brasses of the de Cobham family: the earliest is 1320. The modern view from the same spot features the Leather Bottle inn, patronised by Charles Dickens. Built in 1629, it takes its name from an eighteenth-century find of gold sovereigns in a leather bottle.

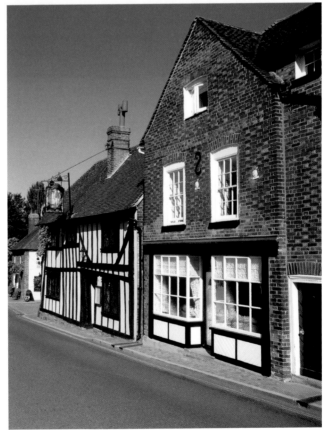

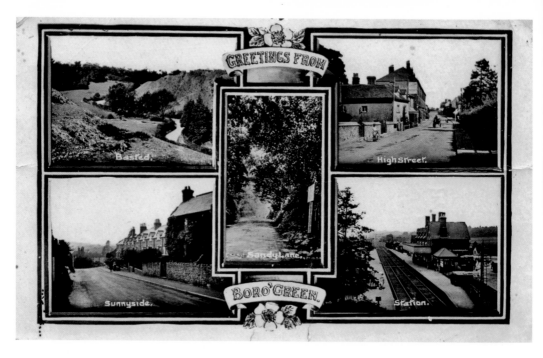

A multi-view card by Hambrook for Borough Green, which includes three of the pictures included in this book.

Acknowledgements

Hambrook's pictures are taken from the collection belonging to Snodland Historical Society, supplemented by others belonging to John Soane and Dean Wooding. My thanks to all these and to Graham Ballard for the modern photograph on page 12.

In the captions I have drawn information from writings by the following, which I gratefully acknowledge:

John Newman, *The Buildings of England: West Kent and the* Weald, 2nd edn. (London, 1976); Jim Sephton (Aylesford); Wyn Burgess and Stephen Sage (Burham); Edward V. Bowra (Ightham); Frank G. Bangay (Borough Green); C. H. Golding-Bird (Meopham); Anne Gough (Trottiscliffe); Anthony Cronk (West Malling); Jane Homeshaw and Clive Thomas (Wrotham).